IMAGES
of America

SPRINGFIELD TOWNSHIP, MONTGOMERY COUNTY

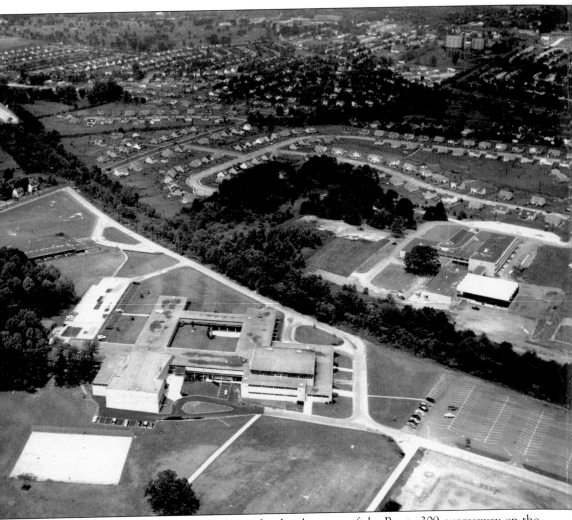

An aerial photograph from 1958 shows the development of the Route 309 expressway on the old Pennsylvania Railroad line. Springfield High School and Enfield Junior High School border both sides of the future highway. By 1960, the expressway had been extended from the exit at Church Road, shown in the upper left-hand corner of this photograph, south past Paper Mill Road, and a tunnel connecting both schools was run underneath the highway.

IMAGES
of America

SPRINGFIELD TOWNSHIP, MONTGOMERY COUNTY

Charles G. and Edward C. Zwicker
with the Springfield Township Historical Society

ARCADIA
PUBLISHING

Published by Arcadia Publishing
Charleston, South Carolina

Printed in the United States of America

Library of Congress Catalog Card Number: 2002110804

For all general information contact Arcadia Publishing at:
Telephone 843-853-2070
Fax 843-853-0044
E-mail sales@arcadiapublishing.com
For customer service and orders:
Toll-Free 1-888-313-2665

Visit us on the Internet at www.arcadiapublishing.com

On the cover: Unlike most orphanages, Carson Valley School tried to integrate the children into Flourtown life as much as possible. This included attending local churches and Sunday schools as well as area schools during the week. From 1921 through 1923, the older girls attended Ambler High School until Springfield High School was opened in 1924.

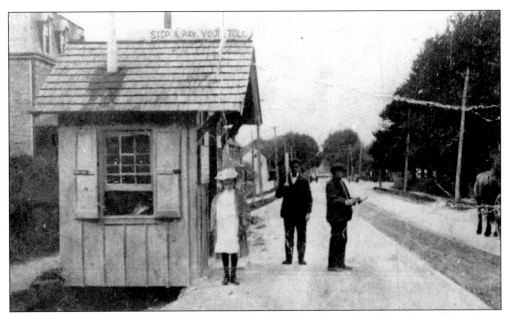

Travelers on the Bethlehem Pike, known earlier as Kings Highway and the North Wales Great Road, paid tolls at this gate at Wissahickon Avenue. The toll operation started in 1804 and continued into the early 1900s. This photograph was taken in 1906.

CONTENTS

PREFACE

Springfield Township Historical Society was established in 1985, largely as the result of the township and its interested residents losing battles to save some of their historic landmarks, including Edward T. Stotesbury's Whitemarsh Hall. A group of very dedicated and energetic individuals founded the society, building it upon the precepts of research, education, and preservation.

Over the past 22 years, the society's membership and its work in carrying out its mission have grown tremendously. It has thoroughly documented through deed research and photography more than 100 of the township's oldest buildings. The society holds presentations and programs, which are open to the public four times a year on topics of local, regional, and worldwide interest. In addition, the society conducts bus trips to historical locations in the tri-state area and beyond for members and nonmembers. It has had all of its research papers, photographs, books, and memorabilia professionally organized and archived. In association with members of the community, the STHS has worked to preserve historic landmarks that were in danger of being destroyed. Examples of these efforts have been the preservation of Paper Mill Run and a privately owned springhouse at the intersection of Pennsylvania Avenue and Camp Hill Road. For the past several years, the society has been trying to save the Black Horse Inn (pictured in chapter 3).

A search continues to find a permanent home for the society to house and display all of its valuable archives, to make them available for further education and research. The authors and STHS thank you for your support in purchasing this book. We hope that you will enjoy reading and perusing it as much as we enjoyed writing it and compiling the photographs. For further information, the society may be contacted by writing to STHS, P.O. Box 564, Flourtown, PA 19031, or by calling 215-233-4600.

—Charles Guenst Zwicker and Edward Charles Zwicker
on behalf of Springfield Township Historical Society

INTRODUCTION

Springfield Township, an area rich in historical significance, has contributed greatly to the growth of Montgomery County and the Philadelphia region. Established c. 1681, the land was given as a gift by William Penn to his wife, Gulielma Maria Springett Penn, and was surveyed as "Penn's Manor of Springfield." Covering 6.16 square miles in area in the southeastern portion of the county, Springfield is laid out in a roughly rectangular shape but with a panhandle that gives the township access to the Schuylkill River.

Springfield's early development and economic growth are directly related to its location. Situated northwest of Philadelphia, it was an area rich in mineral deposits, mostly in the form of limestone and iron ore, and with rich, arable land for agriculture. These resources led to its development as a farming community and as a provider or raw materials to early industries in lime burning and iron ore mining. Many of the early settlers and founders of the area built homes and carved out farms that still exist today.

Springfield's location also made it a way station for the large numbers of travelers and settlers moving along the major roads in and out of Philadelphia. Germantown Pike, Bethlehem Pike, and Ridge Pike were major arteries out of Philadelphia in Colonial times and remain so today. Springfield's location along these highways made possible early settlement and industry in the form of Colonial taverns and inns established to cater to the weary traveler. The Wheel Pump Inn, the Springfield Hotel, the Black Horse Inn, and the Central Hotel (Halligan's Pub) are surviving examples of those early businesses.

The many rivers and other tributaries of the Schuylkill River provided waterpower for numerous paper and flour mills. Wissahickon Creek, Sandy Run, Sunnybrook Run, and Paper Mill Run were but a few. Although many of these waterways have been reduced to minor streams or have vanished due to urban development, the remains of some of the mills are silent reminders of their contribution to the early economic growth of Springfield.

The American Revolution, and specifically the British occupation of Philadelphia in the winter of 1776, brought George Washington and the Continental army to Springfield. Encamped around present-day Fort Washington, prior to marching to their winter quarters in Valley Forge, the Continental army clashed with the British redcoats in a series of skirmishes that covered much of North Woods and Flourtown. Stories abound of the British marching up Bethlehem Pike from Chestnut Hill through Flourtown, officers stopping to refresh themselves at the Wheel Pump and Black Horse Tavern, and a British cannon being hauled up the bell tower of a local church to fire on the fortifications of Washington's army on Militia and Fort Hills.

In the late 1800s, the emergence of railroads and the rail transit system (trolleys) promoted rapid development of local industries, such as iron ore mining. In addition, Springfield Township became more accessible to people living in Philadelphia. Its scenic beauty and countryside attracted wealthy Philadelphians who established summer homes and country estates. Many photographs of this period show the great Stotesbury, Lea, Newbold, and Widener estates, to name a few. Many of the residences in the Wyndmoor section were built as summer homes during this time.

This early era of rail travel made possible the Chestnut Hill Amusement Park, commonly known as White City. It was constructed by the Philadelphia Rapid Transit Authority to establish the trolley system as an accepted form of transportation.

After World War II, Springfield Township experienced rapid growth in population and residential development, as returning GIs and their families looked to the "good life" of suburban living. Between 1945 and 1970, much of the current community infrastructure and residential development was built. You will note some pictures in chapter 9 of buildings that were constructed prior to that time. This is intentional; we wanted to show those buildings that either still exist today or played a prominent role in the community after the war years. Today, only the vestiges of many of the original farms, great estates, early industries, the amusement park, and the trolleys remain in the township. But each of these in its own way helped shape the township, and the people who live here, into the wonderful community that Springfield is today.

This book is arranged in chronological order, with each chapter covering a major time or place in the township's history. Within each chapter, the photographic subjects are grouped by the area of the township in which they currently, or at one time, existed. Since each community could warrant its own book, it was difficult to pare down the hundreds of photographs into this fine collection. Unfortunately, many other noteworthy and interesting buildings, people, and places have not been included due to space; we extend our apologies for those we were unable to include in this volume.

To the past, present, and future residents of Springfield Township, we hope you will enjoy taking a trip down memory lane. Those of you who have only passed through the township, or who have never been here before, come and visit us, and bring your book for a self-guided tour of the area we call home.

One

EARLY SETTLEMENTS

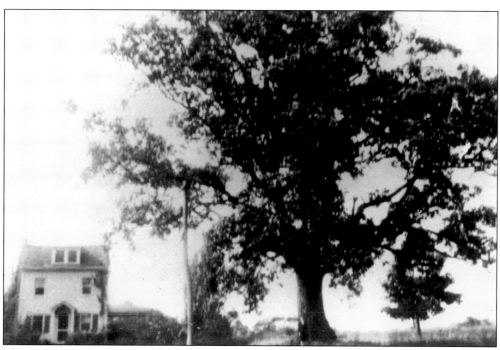

This picture, taken c. 1936, shows the famous Penn Oak. Once a living symbol of Penn's Woods, this tree was located on East Mill Road in Flourtown. The tree was here when William Penn first came to his colony in 1682 and was over 300 years old when it succumbed to old age and disease. The tree gained local notoriety in 1932 when Philadelphia commemorated the 250th anniversary of Penn's landing in Pennsylvania and identified all the local trees at least 250 years old. In 1952, a committee was formed for the preservation and care of the oak while development and road expansion went on around the tree, but by 1975, the tree needed to be taken down. Cross sections of the once mighty oak have been preserved for posterity. The home in this picture is located at 105 East Mill Road and was once called the Acorn because of its proximity to the oak. It was built in the 1860s for one of the Yeakle children.

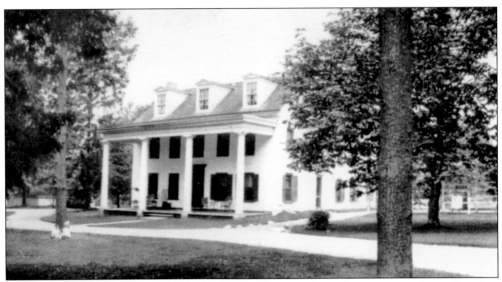

The house named Erdenheim, meaning "earthly home" in German, was situated mainly in Whitemarsh Township but extended into Springfield. The house was built c. 1760 by John George Hocker on his 200 acres. After his death in 1820, the home passed through a succession of owners until 1896, when Robert N. Carson acquired it. (Carson established the Carson College for Orphaned Girls, now called Carson Valley School.) In 1915, George Widener purchased the house. His daughter Eleanor married Fitz Eugene Dixon Sr. in 1912. George Dunton II bought Erdenheim Farms, but dying childless, left it to nephew Fitz Eugene Dixon Jr. For most of the last 100 years, the property has been used for agriculture and breeding and training horses.

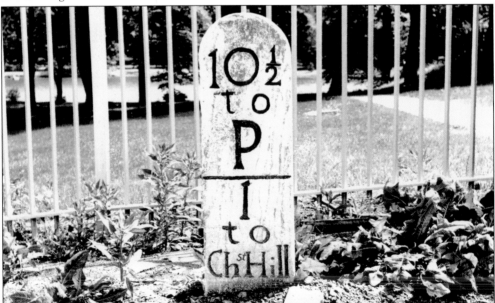

Stone mile-markers were used during Colonial times to indicate distances to and from major towns along the stagecoach lines and main arteries out of Philadelphia, such as the Bethlehem and Germantown Pikes. This marker is still located on Bethlehem Pike (Hillcrest Park is seen in the background), south of the Wheel Pump.

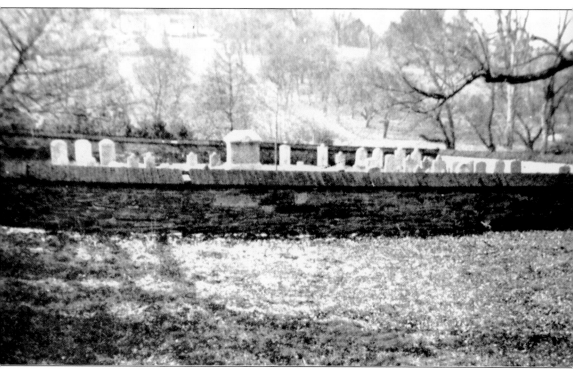

This cemetery is known locally as the Schwenkfelter Cemetery or the Yeakle burial ground and is located east of the former Yeakle land, around Bethlehem Pike and Montgomery Avenue. The burial ground was purchased in 1802 by Christopher Yeakle, his two sons Abraham and Christopher, and his son-in-law Abraham Heydrick for $100.00. According to records, the land had been used as a place of interment since before 1753, and although never verified, it is said that several Revolutionary soldiers who died from wounds at the Battle of Germantown are buried here, as well as British soldiers who were part of General Howe's advance party in the winter of 1777. Christopher Yeakle was buried here in 1810 at the age of 92. Today, the one-eighth acre of ground is part of a private property and is enclosed by a stonewall that was built in the 1880s.

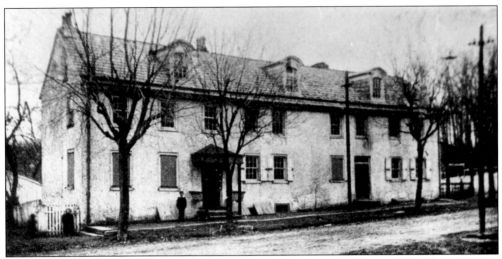

The Heydrick homestead, located at 522 Bethlehem Pike in Erdenheim, was built in 1767 by Abraham Heydrick and remained in the family until 1896. The property functioned both as a home and general store, with the family also operating a sawmill. It was for the Heydrick family that the section of the township now known as Erdenheim was at times called Heydricksdale. After the Civil War, the family operated a machine works behind the house in Yeakle's Meadow for the manufacturing of farm implements. Legend has it that H.H. Heydrick developed the first successful lawn mower, sometime after 1880, in this machine works. Today, the house still stands on Bethlehem Pike across from the Wheel Pump.

John Ottinger originally built this house c. 1736 on the west side of Bethlehem Pike just south of the Wheel Pump. For years, it served as the offices for Marple, Clemens, & Bell Realtors. It is still standing today at 523 Bethlehem Pike and is currently used as a dentist's office. This photograph dates from 1938.

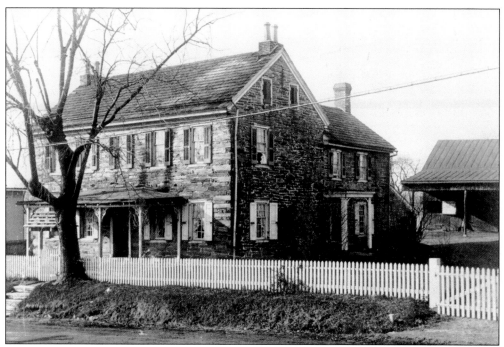

This picture, taken in 1910, shows the home at 1107 Bethlehem Pike in Erdenheim that was built by William Witten in 1746. County tax records indicate that this home was still on the Pike in 1969 but has since been torn down with the property presently being occupied by a commercial building.

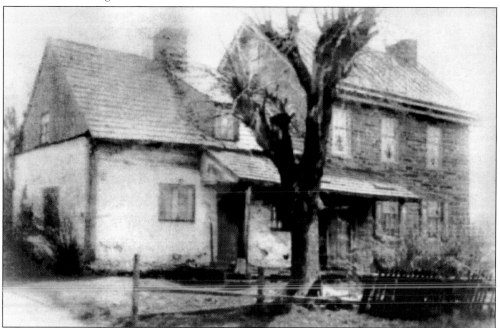

This home was an early farmhouse built in 1742 by William Dixey and was located on the south side of Haws Lane and Bethlehem Pike. The home was demolished long ago, and today stands a commercial building housing a dry cleaners at this location.

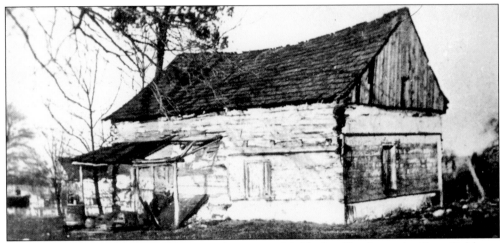

On the east side of Bethlehem Pike, near the present McCloskey Road, was the Capt. Balthazar Heydrick home, built in 1741 by William Nice. Heydrick (1750–1831), a Schwenkfelder and militia captain in the American Revolution, was one of the few members of the Schwenkfelder families to enter the military. After the war, he was appointed special assessor for Springfield to fix damage sustained by the residents during the British occupation. His house was still standing as late as 1885, the last log house in the lower part of Montgomery County. A gas station now occupies the site.

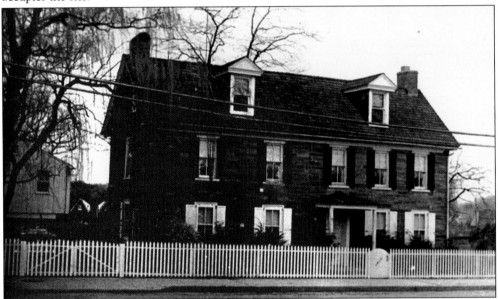

Located at 1415 Bethlehem Pike, this home was built in two sections. Originally part of a 75- to 85-acre property, it was sold to Reynor Tyson by the Penn family in 1741. Tyson, an early land developer, bought land for resale in what is now Flourtown. By 1743, the land had been sold for 30 pounds to John Barge, who built the first section. In 1765, Jacob Miller purchased the house for 266 pounds and built the second portion. Miller served in the Revolution from 1777 to 1781 as a private with the Associators and Militia and lived in the house until his death in 1815. Over the years, the acreage shrank and numerous families owned the house, which was used by Carson Valley School as a library c. 1916 and was known as Darwin Hall. Today, the building houses Dan Helwig Realty and looks much the way it did in the 18th century.

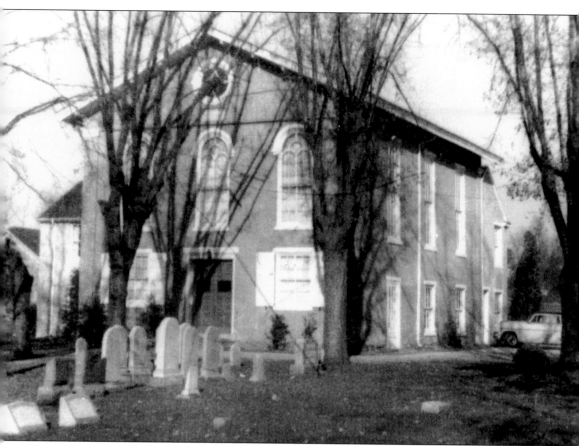

Located at East Mill Road and Bethlehem Pike is the First Presbyterian Church of Flourtown. The first congregation met in 1855 in a small schoolhouse until land was purchased for this building to be constructed on the present site. The congregation raised $4000 to build the church, which was completed in January 1858, and for many years it was the only church in the township. The church and the graveyard comprise about three acres. Expansions to the church began in the late 1800s, and since then it has been expanded several times to accommodate a growing congregation and supplemental activities.

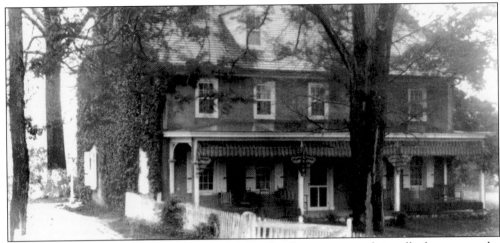

Located at 500 East Mill Road in Flourtown, this home was traditionally known as the Nice-Yeakle house. The house was built in three stages, taking place in 1742, 1816 and 1850. In 1741, the land was surveyed to William Nice, who built the earliest part. Abraham Yeakle, his son Jacob, and his grandson William all owned and added on to the home through the years. William Yeakle died in 1909, and 110 acres of the estate were sold off to the Sunnybrook Golf Club in 1914–1915; the home was then used as a clubhouse. A portion of the property was later sold for the construction of Flourtown Gardens. The township acquired the remainder of the course, including a later clubhouse north of Haws Lane, in 1957. Today, the home, shown here in 1915, is a private residence.

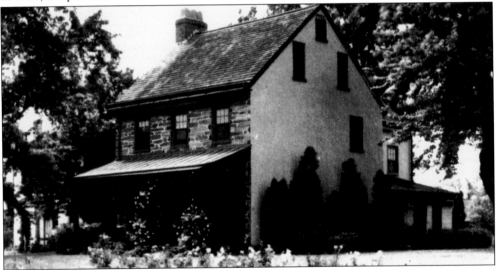

The Streeper family first settled the Bloomfield property in the 1680s. In 1761, William Streeper constructed a mill on this land, which operated through the Colonial period and was the site of a skirmish between the British army and Continental soldiers. This farmhouse and adjoining barn were built prior to 1892, when they were sold to George Thomas for $10,000. In 1914, Bloomfield was purchased by John Morris and his sister Lydia and added to their Compton estate on the south side of Northwestern Avenue. The siblings, world travelers devoted to horticulture and botany, brought ideas, plans, and plants to the estate, forming the basis for the beautiful landscape still in evidence today. Upon Lydia's death in 1932, the property was willed to the University of Pennsylvania and became the Morris Arboretum.

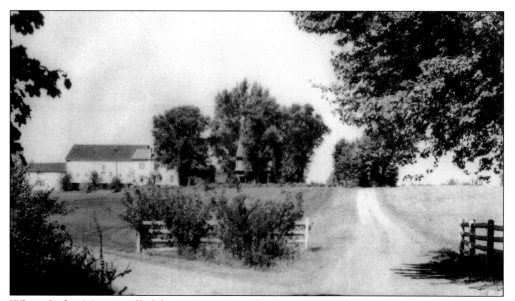

When Lydia Morris willed her property to the University of Pennsylvania in 1932, both Bloomfield Farm and Compton became collectively known as the Morris Arboretum. The Bloomfield property included four residences, the Springfield Mill, a barn, and number of outbuildings. The buildings currently serve as residences and staff facilities for the arboretum. This view of the property from Northwestern Avenue has remained virtually unchanged to present day.

Henry Dewees built this house on Northwestern Avenue c. 1738. Dewees's father, William, built and operated the country's second paper mill c. 1708 in Chestnut Hill. Henry later operated his own paper mill, which during the Revolution manufactured cartridge paper for the American patriots. He is buried along with his father in the Upper Germantown Burying Ground. The house has been expanded over the years, but the core of the original house can still be seen in the basement.

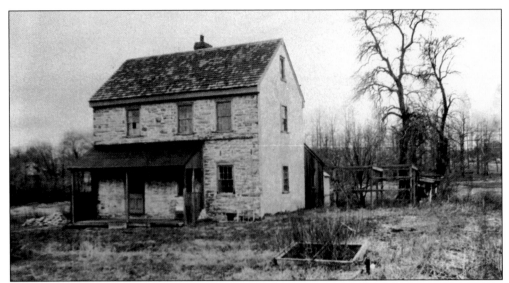

This house was located at 527 Mermaid Lane in Wyndmoor and was built by John Groethausen c. 1709. Groethausen most likely raised his family in this house before moving into the larger family home at 901 Abington Avenue built by his father.

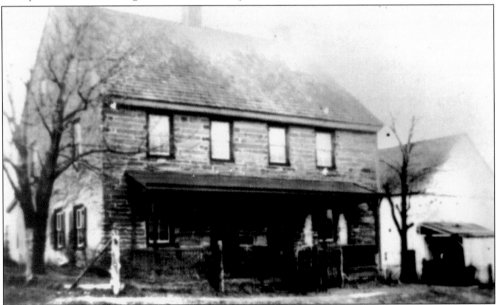

Herman Groethausen built this stone house at 901 Abington Avenue in 1742 at the age of 72 and survived only one year after its completion. Quite a large house for its period, the dwelling is organized in a traditional Germanic plan with a massive, centrally located cooking fireplace measuring 6 feet high by 14 feet wide. With his original land grant, Groethausen acquired approximately 580 acres of land. Upon his death, the property was distributed amongst his heirs and sold, with the house tract held by his son John. Sixteen years later, John conveyed the property to his brother-in-law, Christopher Ottinger Jr., and it remained in the Ottinger family until 1839. Each subsequent sale further reduced the size of the house tract. The Herman Groethausen house is one of Wyndmoor's earliest residences and is a well-preserved example of mid-18th century Germanic architecture.

Henry and Barbara Fisher built this house c. 1873 on five and a half acres that they purchased from Samuel Rex. The home would stay in the Fisher family, with one eight-month exception, until 1921 when it was sold to William A. Matteram. The Matteram family lived here until 1944, when they sold the home to Robert Killough. Killoughs remained there for over 20 years until 1964, when Louis and Helen Bechtle moved in. The house, which still stands today, has had additional owners since then but not that many considering its 129-year history.

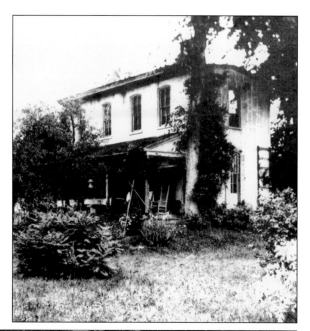

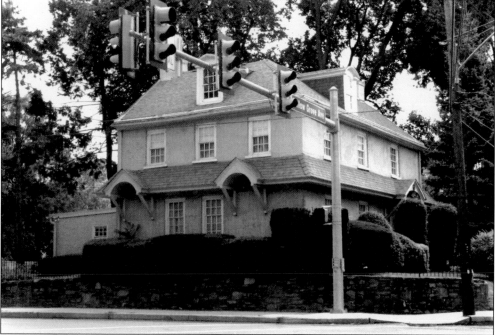

The Harmer family owned considerable acreage in the Springfield area, and William Harmer erected this house at 1524 East Willow Grove Avenue. The original house may have been built in the early 1700s. Several additions have been added through the years, resulting in its unusual shape. Various features of the house indicate these additions were added at different times. Harmer's descendent, Benjamin Harmer, sold 61 acres plus the house to Jacob Fisher in 1770. The property remained in the Fisher family until its sale in 1824 to Andrew Ardman, a Chestnut Hill farmer. The house and property continued to pass through several owners in the ensuing years, until the current owners purchased it in 1984.

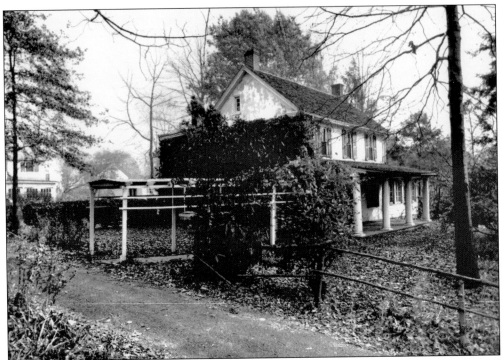

Joseph Harmer built this Colonial farmhouse c. 1756, and it is still a residential home located at 7827 Eastern Avenue in Wyndmoor.

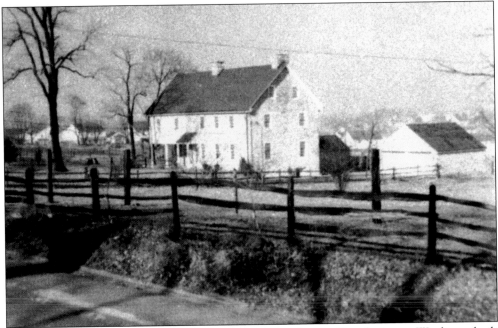

Located at 1101–1105 Paper Mill Road in Erdenheim is the pre–Revolutionary War house built by John Ottinger c. 1740. John was the son of Christopher Ottinger, whose home is located on Bethlehem Pike in Erdenheim. John lived on the portion of his father's farm willed to him, on which his descendants lived until after the Civil War.

John Krieble, who sold the property to Clayton Platt in 1851, built this Victorian home, which stands at 800 Paper Mill Road in Erdenheim. Platt was the owner of the Graystock Estate in Wyndmoor. This photograph from the 1970s shows a later addition on the back of the house.

The Enfield Tea Room was built c. 1790 on land that was originally occupied by farms owned by descendants of early German settlers, including the Yeakles, Ottingers, and Shrivers. Located at what was once called Five Points on Church Road, it is better known today as the location where Church, Paper Mill, and Oreland Mill Roads intersect. This locality once held great deposits of iron ore and clay, which were mined by farmers and became the basis for the Enfield Pottery and Tile Works. The house is currently operated as a dentist's office and residence.

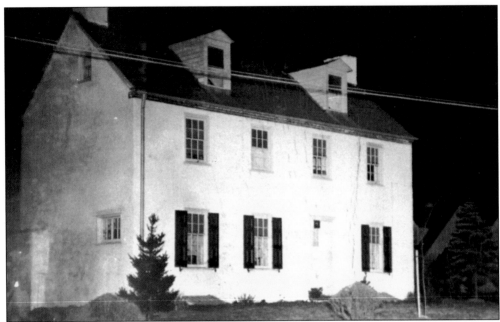

Probably the oldest surviving house in Oreland, the George Dunnet house is located at 415 Oreland Mill Road and was built c. 1745. The property still retains the original root cellar, carriage house, and 40-foot well. A portion of the original property, extending across Oreland Mill Road, was used as a private burying ground where two of Dunnet's children were buried. The property was abandoned at various times throughout its history, but since 1985 has been beautifully restored by the current owners.

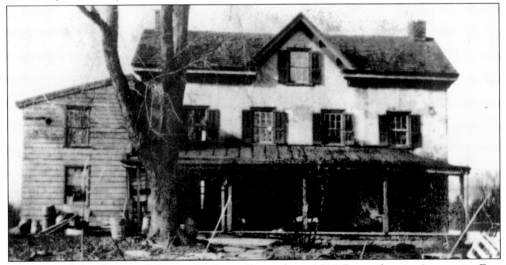

The original farmhouse of George Emlen still stands at 1616 Pennsylvania Avenue in East Oreland. The original structure of this house was a log cabin dating from c. 1711 and belonging to the Scull family. During the Revolution and Whitemarsh Encampment, this home served as quarters for General Washington's staff and was visited by General Lafayette. In 1938, Dr. J. Mervin Rosenberger acquired the property from Jabob Rech and conducted extensive renovation. He sold the property in 1940 but then reacquired the home in 1961. Today, it exists as a beautiful example of a Colonial farmhouse from that era.

Two

FARMING AND INDUSTRY

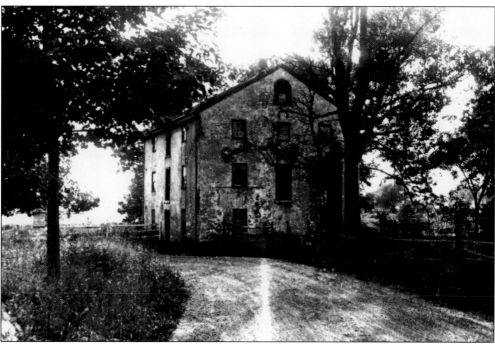

Gristmills provided a way for early settlers to grind their grain, and the earliest mills in Springfield dated back to the early 1700s. Records indicate that Skippack Pike was established to allow farmers from as far away as Salford Township to bring in their grain. The Springfield Mill is located on the Morris Arboretum property in the panhandle section of the township. William Streeper built the original gristmill, powered by a waterwheel, in 1761. The present structure was erected by John Piper in 1854 and was used as a grist and sawmill, powered by a turbine. The mill ceased operations in 1907. This is one of the last mills still standing on the Wissahickon, and it retains its working parts. The Springfield Mill is listed on the National Register of Historic Places.

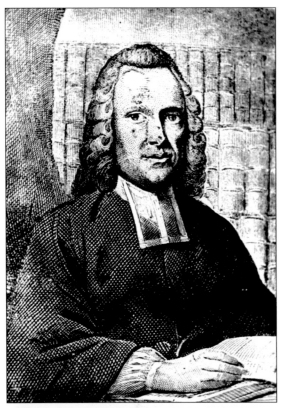

The Reverend Michael Schlatter was an 18th-century minister of the Reformed Church, which operated near Stenton Avenue and Paper Mill Road. Schlatter, born in Switzerland and educated in Holland, came to America in 1746 and was one of the founders of the Reformed Church in this country. During the French and Indian War, he was a chaplain in the British army, but during the Revolutionary War he refused to serve. In 1777, when the British invaded Germantown, the British army took him to Philadelphia and imprisoned him for a time. He owned a tract of 135 acres extending from Paper Mill Road to Willow Grove Avenue, and his house near Stenton Avenue and Gravers Lane remained standing until 1867. He built another home on land that he owned on the east side of Germantown Avenue beyond Chestnut Hill Avenue, in which he lived until his death in 1790.

Once located on Paper Mill Run, upstream from where it passes under Paper Mill Road in Erdenheim, this mill was built as a paper mill by Rev. Michael Schlatter c. 1760. Sources indicate that Schlatter sold the mill in 1765 to John Scheetz, who continued the milling operation. In 1776, the land and mill were sold to Thomas Coombe. Remnants of the mill and other related buildings, which are on private land, are still visible today.

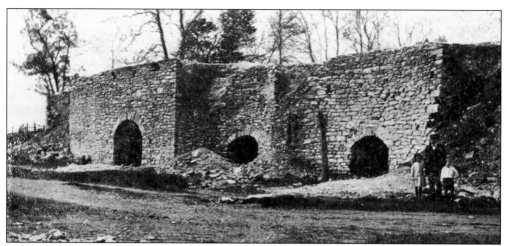

Much of Springfield Township rests atop a limestone layer, which is easily accessible and of good quality, making lime burning one of the area's earliest industries. The limestone was quarried, placed in ovens or kilns (as in this picture of Yeakle's Lime Kiln, built *c.* 1776), and burned to a fine powder that was used in the production of mortar or to sweeten the soil. Springfield had three kiln operations, all located in the Oreland section, where there were large lime deposits.

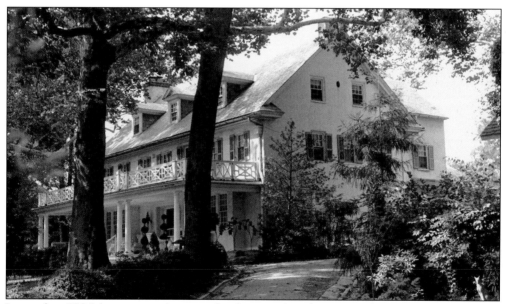

Located at 200 Montgomery Avenue, this house is best known as the Yeakle Homestead or Erden. Jasper Scull built the earliest part of the house in 1728. Christopher Yeakle purchased the property in 1762 and 1764. The farm was rented until his son Abraham purchased it in 1783, and it passed through the family until Daniel Yeakle sold it in 1892. The Yeakle meadow across the street became the Chestnut Hill Amusement Park (White City). Henry Auchy, the general manager of the park, purchased the house, which served as his home and as a teahouse for the park. White City closed in 1911, and the house was later purchased by William W. Harper, who saved it from demolition, and later by J. Morris Wistar in 1929. The house and barn have been divided into two separate properties in recent years and are both privately owned at this time.

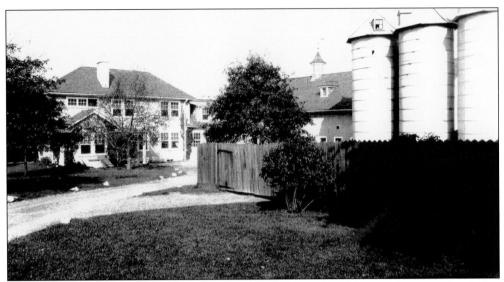

Cinchona was the property owned by Ethel W. Benson. The farmhouse and barn are located at 405 Haws Lane in Erdenheim and were built between 1916 and 1925. The architectural firm of Mellor, Meigs, and Howe designed a swimming pool and bathhouse in 1925. Today, the house looks much the same with the exception of the three silos and fence that no longer extend in front of the property.

This Dutch Colonial is located at 417 Haws Lane and was built to be used as a tenant house for the Cinchona-Benson property. Today, it is a residential home. On the right hand side of this picture, past the fence line, one can view the Fort Washington line of the Pennsylvania Railroad, which is today the Route 309 expressway.

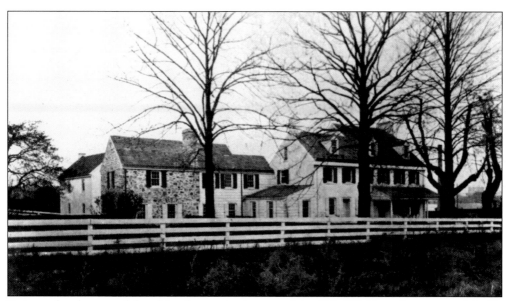

Estimated to be one of the oldest houses in the township, 604–608 Grace Lane was originally the manor house of Orchard Lane Farm and was built prior to 1770. The house has six fireplaces, and a tree trunk in the basement is the main structural support beam. The original owner, Lynford Lardner, was involved in real estate, mill operations, and limestone quarrying and built this home on a 99.75-acre tract of land. Today, the property retains most of the outbuildings and the barn.

This entranceway to a cottage located on the Carson Valley School property shows the beautiful tile once produced by the Enfield Pottery and Tile Works. Joseph H. Dulles Allen started the operation in 1906 for the manufacture of artistic pottery and tiles. Allen bought the Yeakle farmhouse property and started Enfield Pottery and Tile Works. The surrounding community was named Enfield when a post office by this name was established to process the large amount of mail generated by the business. The pottery shut down in the early 1930s, and the post office closed. Oreland threatened to absorb Enfield, although in the 1940s and 1950s a station of that name was maintained on the Fort Washington Branch of the Pennsylvania Railroad. In 1947–1948, Springfield Township opened a new $274,000 schoolhouse called the Enfield School. More than 200 children were enrolled the first day, preserving the name for the future.

In 1702, the William Penn family gave a warrant to Nicholas Hicks for 100 acres. He built a home and farm on Church Road in Wyndmoor. His grandson William would later receive clear title to the land by descendants of William Penn in 1786. The farming plantation stayed in the family until 1820, when it passed through a succession of owners: Samuel Coughlin, Mary Ottinger, and Arnold Aiman, among others. Today, the main home still exists and is privately owned. The 100 acres were sold off to different developers. Homes were built along upper Edann Road in the late 1920s and lower Edann Road and the adjoining streets in the 1950s.

Three

TAVERNS AND INNS

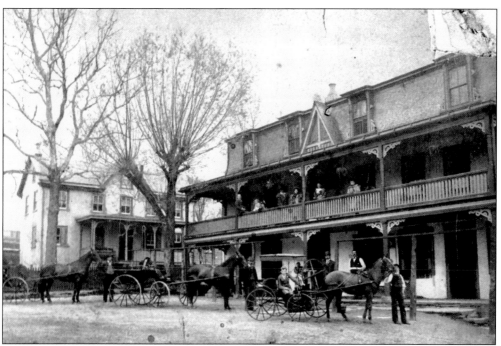

Located at 529 Bethlehem Pike, the Wheel Pump was built c. 1735 and was continually operated as an inn until the present day. William Harmer purchased the land in 1715 from William Penn. In Colonial times, the village that surrounded this inn was called Wheel Pump, later Heydrick's Hollow, Heydrick's Dale, and finally Erdenheim. The village consisted of Christopher Yeakle's house at 200 Montgomery Avenue, the Heydrick House, and the Wheel Pump. The Wheel Pump Tavern was also known as the Washington Hotel prior to 1877, based on deed research from that time period.

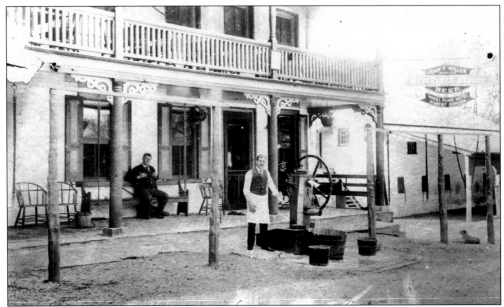

Owing to its distance from the city and because it was before the introduction of railroads, the inns of Flourtown became noted stopping places for travelers. The Wheel Pump was the first of the inns located on Bethlehem Pike as one traveled north out of Philadelphia into Springfield. Tradition states that the name was derived from a wheel pump in use here since before the Revolution. This picture taken in 1897 shows a still-operating pump.

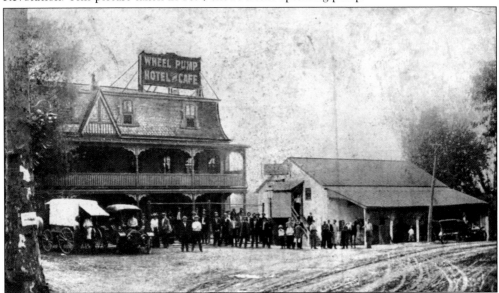

Abraham Heydrick was another one of the numerous owners of the Wheel Pump through its long history. Abraham was born in 1742 and served as a private in the Revolution. He married Susanna, daughter of Charles Yeakle, in 1767 and ran the Wheel Pump as a store and hotel. He built his home across from the Wheel Pump in 1767, served as overseer to the poor in 1774–1775, and died in 1826. He is buried in the Yeakle burial ground. Legend had it that Heydrick accumulated a great deal of Continental money, which he stored in barrels, leading to the statement that he had a "barrel of money."

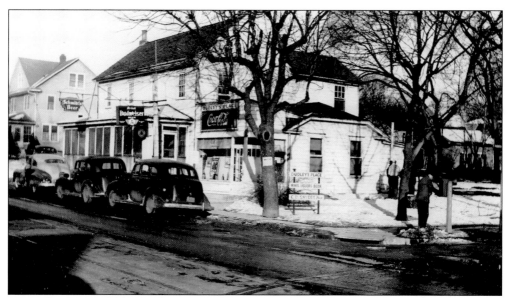

Located at 700 Bethlehem Pike in Erdenheim is the restaurant now known as Fingers. Portions of the house are thought to have been built prior to 1779. It is believed to have been used as the tenant house for the Yeakle estate at 200 Montgomery Avenue. In the 1940s, it was owned and operated by C. Dudley Snyder as a tavern and was known as Dudley's Place, where Synder insisted that "the customer is never right."

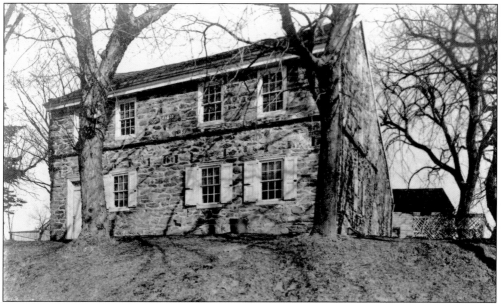

Another fine Colonial farmhouse is located on the east side of Bethlehem Pike at Chesney Lane. A date-stone on the house, which is still in excellent condition, reads, "COMO 1743," for Christopher Ottinger and Maria Ottinger. In 1742, Ottinger bought five acres from Reynor Tyson on the Great North Wales Road and built his house in 1743 as his "window on the Pike." Most records indicate that he operated this property as Ottinger's Inn; in his will, he refers to himself as an innkeeper. It continued as an inn into the 1800s. The Ottingers were residents of the Erdenheim area for over two centuries. Alfred and Gertrude Manning restored the house in 1940.

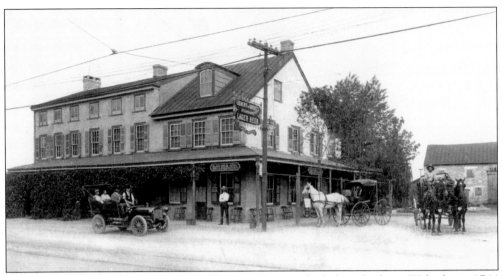

The Black Horse Tavern at 1432 Bethlehem Pike was built by Abraham Wakerly in 1744 and consisted of a two-and-a-half-story building with a one-story kitchen in the rear. The first section served farmer, lime-carrier, and traveler, and after 1763, stagecoach passengers on the Philadelphia-to-Bethlehem line. With the growth of trade and travel, new owner Jacob Meninger added a three-story addition on the north end in 1833. Prior to 1840, it was known as the Sampson and the Lion. The McCloskey family owned the inn for three generations, from 1880 to 1990. It was a stop for farmers on their way to local flourmills in Flourtown and later used for meetings of the Society for the Apprehension of Horse Thieves, township commissioners, voting, and horse trading. Until about 1980, cattle grazed on the lawn next door, part of the inn's property. Today, the tavern stands in derelict; the ground will most likely be redeveloped for commercial purposes, with the building either moved or torn down.

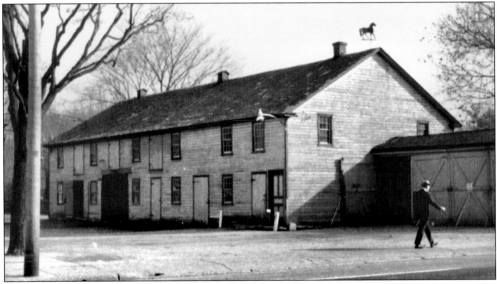

An old black horse weather vane adorned the barn behind the Black Horse Tavern. The original stone barn was built prior to 1780, with a frame barn added to the structure after 1798. Among its many uses, the barn was once used for voting. This barn was torn down years ago, although a smaller barn still remains on the property behind the tavern.

32

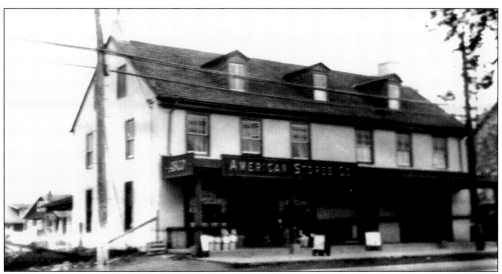

One of the early inns in Flourtown, the Eagle served farmers, Revolutionary War soldiers, and stagecoach passengers and was one of many old Colonial taverns along the North Wales Great Road. Built in the 1760s, it was known for a long period as Slifer's but was also called the Eagle and Kenner's Inn. Slifer also operated a feed and grain store next to the hotel. It ceased to be a tavern in the mid-1880s and became the site of Flourtown's first grocery store, then called the American Store (predecessor of Acme), in 1926. The property was located at 1507 and 1509 Bethlehem Pike, a few doors north of what is today Starbucks Coffee shop. Bob's Antiques & Used Furniture and Flourtown Tailors occupy the building today.

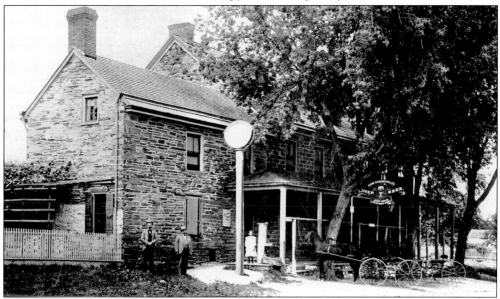

This tavern, located on Bethlehem Pike near Mill Road, had many names and many changes to its structure since Christopher Rex built it in 1765. Known originally as the Central Inn, it later became known as Kline's Tavern, Farmers and Citizens Hotel, Wagons and Horses, more recently the Block and Cleaver, and Block and Candle. The 1798 direct tax lists indicated it as a two-and-a-half-story stone building with a stone barn. As Halligan's Pub, located on Bethlehem Pike near Mill Road, it still serves many travelers.

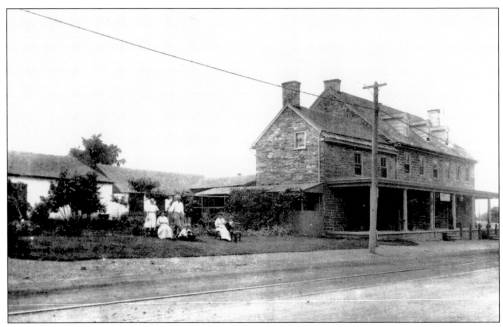

This is a later view of the Central Inn, or Halligan's Pub.

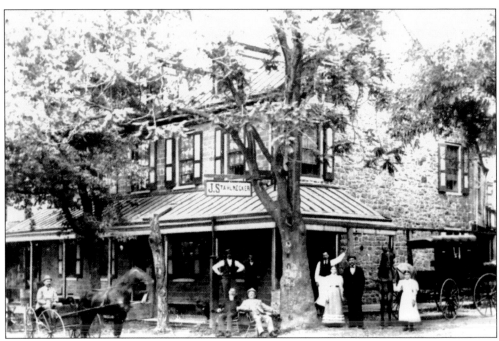

John Bitting built the Green Tree Inn in 1811, on land that he purchased in 1804, to cash in on the lucrative stagecoach business and farm trade on Bethlehem Pike. The Bitting family ran the hotel until 1865 when it was sold to Charles Streeper, who renamed it the Springfield Hotel. Other proprietors included Jacob Stalnecker and the Rotzel brothers, Edwin and Oliver. It currently operates as the Sorella Rose Bar and Grille.

Four

RAILROADS AND TROLLEYS

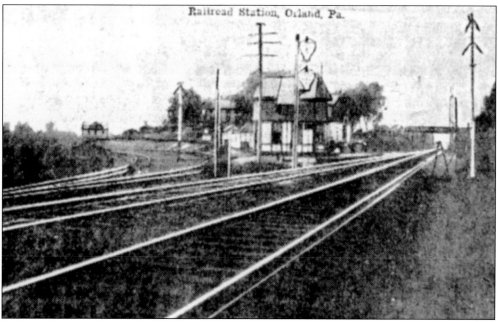

Railroad Station, Oreland, Pa.

The first railroad to pass through the township was the North Pennsylvania Railroad, established in 1852, which later merged into the Reading Railroad in 1879. The Oreland train station was built in 1855, the name being derived from the presence of large iron ore deposits in the area. There was much activity on this line as a result of local stone quarries, the blast furnace at Edge Hill (now North Hills station), and the limekilns at Sandy Run station (now Felwick station). Because of significant switching activity, a large roundhouse was built at Oreland, located behind the present-day post office, which remained in operation until *c.* 1900. Today, this station is operated by the South Eastern Pennsylvania Transit Authority (SEPTA).

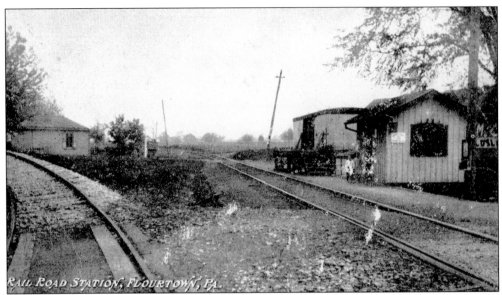

The Flourtown train station on Bethlehem Pike was part of the line established by the Plymouth Railroad, which later merged into the Reading Railroad and extended from Conshohocken to Oreland where it formed a junction with the North Pennsylvania Railroad. Flourtown became an important station for passenger and freight traffic. Passenger service continued through the Flourtown station until the 1930s and freight traffic until 1950. Up until the late 1970s, an occasional train was sent down this line, but only a sign bearing the legend "Flourtown" remained as a symbol of this once busy station. This view is looking east from Bethlehem Pike down the line to where it crossed over Church Road on its way to Oreland.

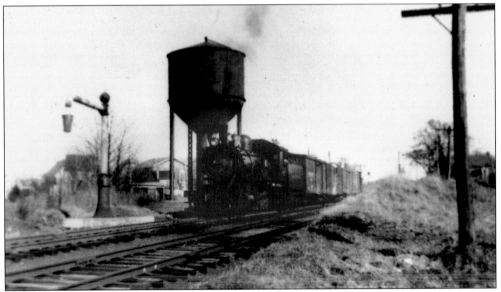

This water tower was part of the Reading Railroad line through Flourtown and was located west of Bethlehem Pike before the trestle over the Wissahickon Creek. Here, the engines would pull onto the siding to take on water prior to continuing their run. This rail line through Flourtown served as a spur line running east-west and connecting the Reading lines with the Pennsylvania Railroad in Plymouth Township.

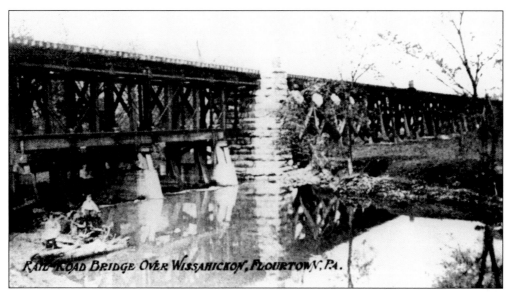

RAILROAD BRIDGE OVER WISSAHICKON, FLOURTOWN, PA.

This trestle bridge over the Wissahickon Creek was built in 1883 for the Reading Railroad line and provided a crossing for the trains coming in and out of the Flourtown station. This bridge is still in existence today, located on the border of Whitemarsh and Springfield Townships, and can be seen behind the Flourtown Commons on Bethlehem Pike.

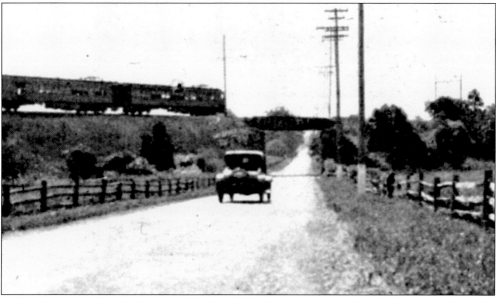

A then-modern electric train approaches the overpass on Church Road. The Pennsylvania Railroad built its Cresheim Branch from Mount Airy, through Wyndmoor and Oreland, to Whitemarsh in 1884. The route of the Whitemarsh line was established partly for the convenience of I.D.H. Ralph and Edward Stotesbury, who had estates in the area. The East Lane station was placed so that Stotesbury could ship the horses he raised right from the gates of his Winoga Stock Farm. Ralph had the Arlingham station located on his estate, Arlingham, now the Sandy Run Country Club. This line has been out of operation since the 1950s, and part of the Route 309 expressway follows its roadbed.

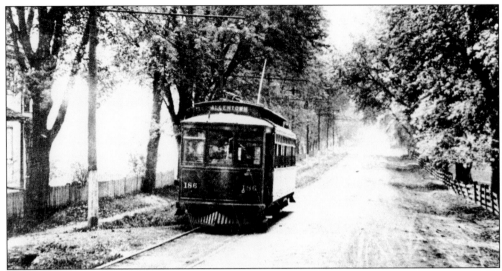

In addition to the railroads, transit companies began to lay down tracks into the township in the late 1800s, leading to the increase in population, commerce, and growth. This photograph shows a Lehigh Valley Transit Company (LVT) car on Bethlehem Pike, north of Valley Green Road. In 1900, the Inland Traction Company surveyed a trolley route down Bethlehem Pike through Flourtown to Erdenheim. This route was later taken over by the LVT, which completed laying the rails and, in 1902, ran the first trolley car from Flourtown to Erdenheim. The Lehigh Valley Transit Company ran its well-known red trolley cars up and down the Pike until the line ceased operations in 1926.

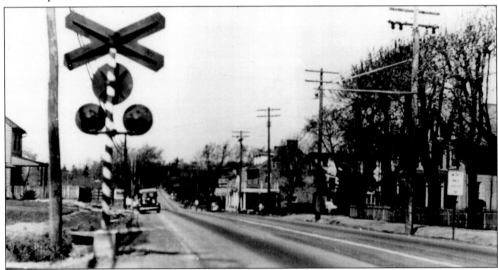

The LVT's lines ran on Bethlehem Pike, between Allentown and Erdenheim, from 1902 until 1926. Prior to 1903, the line was inconvenienced because the Reading Railroad refused to permit a physical crossing of its tracks at Flourtown, seen here. The cars came as far as the railroad lines, where the passengers had to alight, walk across the tracks, and board another car on the other side. The LVT "stole" the crossing this year by building a trolley track over the railroad after the last train for the day had passed. A trolley car was then run across before witnesses, which constituted legal permission. A through line between Allentown and Erdenheim was thus established.

Because of the population and commercial growth rapidly developing this area, the Union Traction Company (UTC) of Philadelphia extended their tracks from Chestnut Hill to Northwestern Avenue. The UTC was later merged into the Philadelphia Rapid Transit Company (PTC), who in 1897 ran these lines from Germantown Avenue over Hillcrest Avenue to Bethlehem Pike. The PTC opened Chestnut Hill Amusement Park in 1898 as a way to increase attendance on their lines. People rode the trolleys from the city and points north to spend a day at White City.

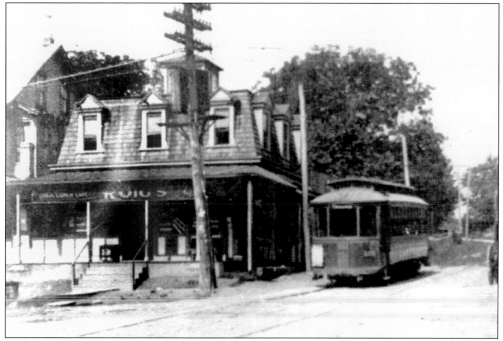

This building, now known as Bruno's, was a sandwich shop and trolley terminus for the Philadelphia Rapid Transit Company in the early 1900s. Located at Northwestern Avenue and Germantown Pike, in the panhandle section of the township, the building dates back to c. 1877.

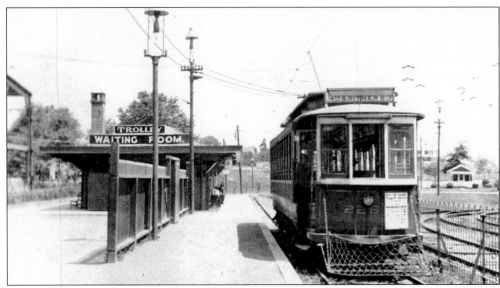

Neither the Philadelphia Rapid Transit Company nor the Lehigh Valley Transit Company had a station or terminal at Erdenheim prior to the summer of 1907, when a trolley station was built on the grounds of the Chestnut Hill Amusement Park and named the Union Trolley Terminal. The building was used as the trolley waiting room and also served as a post office for Erdenheim after 1910, continuing in operation until 1926.

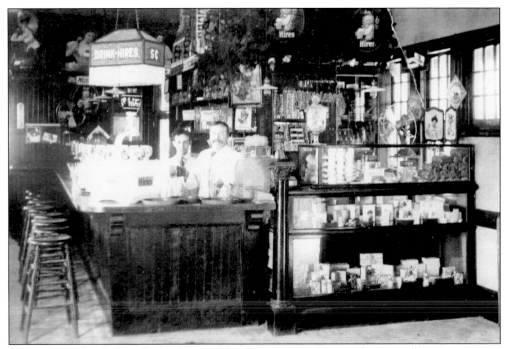

Advertising a "Light Lunch—Cigars and Candies" on the sign outside, the trolley waiting room building housed a soda fountain (Hires Root Beer for 5¢) and sold assorted sweets for passengers waiting for the next trolley.

Five

WHITE CITY

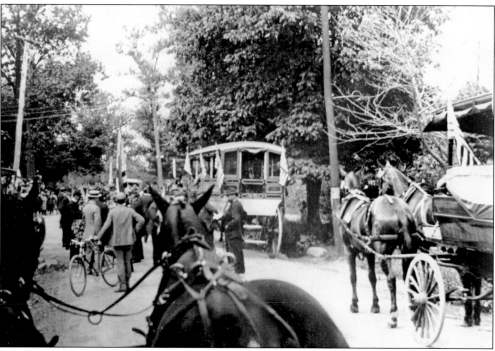

People arrived at the Chestnut Hill Amusement Park through one of two main entrances. This one off Montgomery Avenue was the larger of the two. Many modes of transportation were used to get to the park, including bicycles, trolleys, and horse-drawn carriages, and visitors also walked there. For those who arrived by trolley, a terminal stood at the far end of the park, behind what is today Rittenhouse Lumber & Millwork Company. The two lines, which converged at this terminal, belonged to the Union Traction Company (approaching from Philadelphia) and the Lehigh Valley Traction Company (approaching from the north). The terminal, originally built in 1906, was later home to the Flourtown Post Office, and it still exists today, as part of the lumberyard.

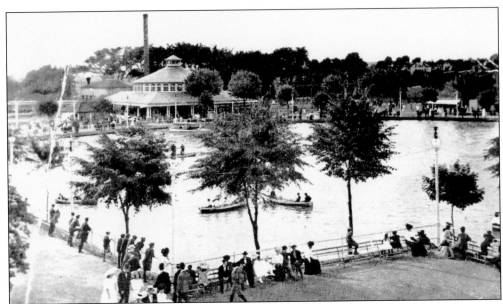

This is a view of the park, probably taken from the top of the Grand Casino building, looking west towards Bethlehem Pike. The ground that the park stood on was once known as Yeakle's Meadow and Yeakle's Pond, both belonging to Daniel Yeakle, who lived across the street at 200 Montgomery Avenue. Later known as the Wister House, it once belonged to Henry Auchy, general manager of the park. Visible in this picture is the tower for the Wheel Pump power station, located behind the carousel, which provided electricity for the park and surrounding area.

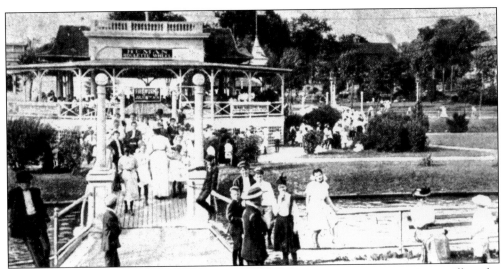

The bandstand was strategically located on an island in the middle of White City to allow the patrons to enjoy the music from all areas of the park. The bandstand was home to many famous and not-so-famous bands of the early 1900s, but none so popular as John Phillip Sousa. In the summer of 1903, many park employees, including the entertainment of the day, were repeatedly fined for working in violation of the Sunday Observance Laws. This view was taken from the Grand Casino and looks beyond to Montgomery Avenue.

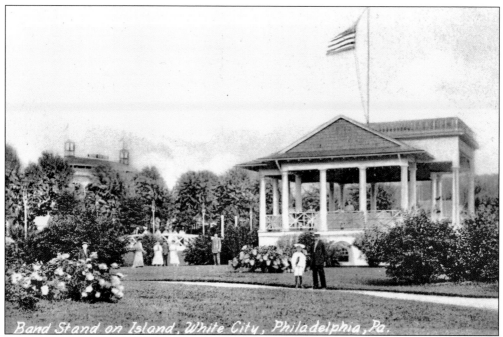

Band Stand on Island, White City, Philadelphia, Pa.

Here is a view of the bandstand looking east towards Paper Mill Road. The top of the Mountain Scenic Railway is seen to the left. Today, the bandstand is long gone, as is the island in the middle of the lake. The lower part of the lake, including the island, was backfilled to provide the football field for the high school. The remainder of the lake is now known as Hillcrest Pond.

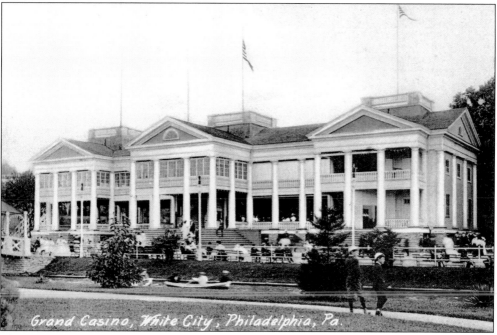

Grand Casino, White City, Philadelphia, Pa.

The crown jewel of the park was the Grand Casino, designed by Horace Trumbauer, who later was the architect for Edward Stotesbury's Whitemarsh Hall. There was no gambling at this casino, unlike its modern-day namesakes, but it was home to dancing, dining, and entertainment.

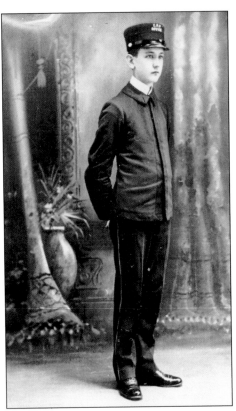

Young Walter Scott was one of the attendants in the Grand Casino building. Not only were the park employees well dressed, the patrons were expected to adhere to a dress code as well.

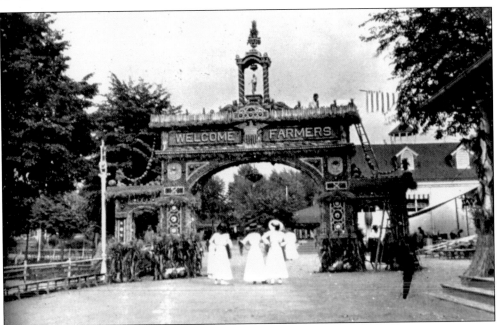

Often mistaken for the main entrance, this large archway welcoming the local farming population was built of various fruits and vegetables. The management recognized, and patronized, the large farming community in the area as a target audience for the park.

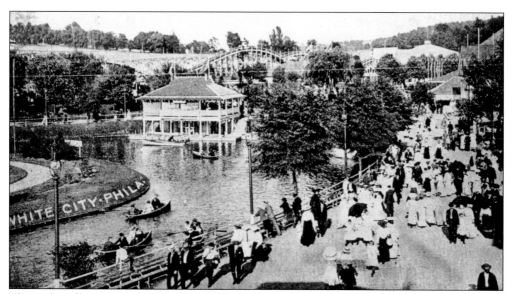

The park's official name was the Chestnut Hill Amusement Park, but locals adopted the more familiar name of White City instead. This was derived either from the whitewashed painting of the buildings or after the more famous White City amusement park in Chicago. The park opened in May 1898 and closed after the 1911 summer season. The land was sold in 1912 to a group of local developers for $500,000. They in turn eventually sold it to Springfield Township in 1923 for one dollar; and the land was used for the construction of the first township high school, Hillcrest.

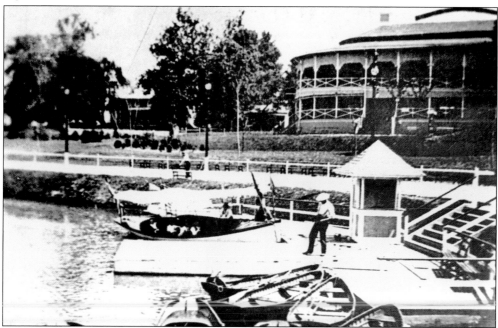

This landing and concession stand were located at the boathouse, where men would rent boats to take their families or girlfriends out on the lake for some private time and to listen to the music emanating from the bandstand. The Mountain Scenic Railway is shown in the upper right-hand corner.

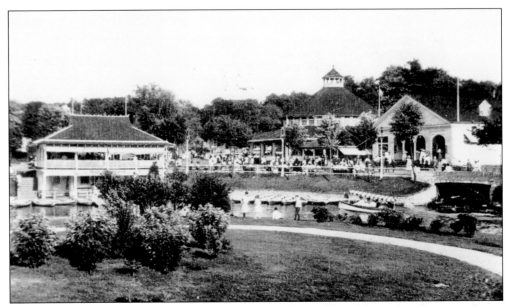

This picture, taken from the bandstand and island in the middle of the park, offers a good view of the boathouse, second carousel, and theater. The park had two carousels, both built by the Philadelphia Toboggan Company. Chester Albright and Henry Auchy founded this company. Auchy would help oversee management of the park during its entire 13-year history. As their name indicates, the company's primary product was toboggans, known today as roller coasters, with the carousels frequently being thrown in to help close a deal with the park. They were typically leased for 3 to 5 years and then were purchased or removed for resale to another park.

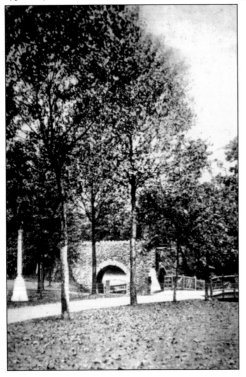

Known as Lover's Lane by many of the younger generation in those days, this stone bridge at the south side of the park provided an overpass for Paper Mill Road to cross over Paper Mill Run. The creek ran through the park, flowing into the lake, which today is known as Hillcrest Pond.

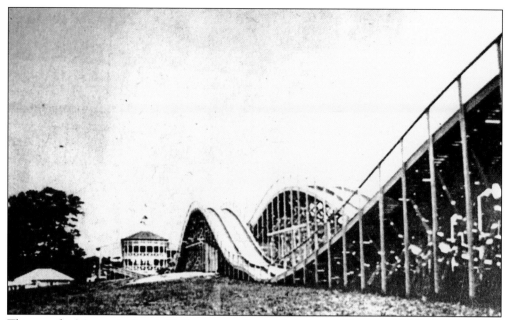

This was the Mountain Scenic Railway, one of two toboggans at Chestnut Hill Park, as pictured in 1899. The toboggan ran parallel to Montgomery Avenue. In 1907, one of the toboggans was struck by lightning and burned to the ground. It was rebuilt the following year by the Philadelphia Toboggan Company, the firm that built them originally. This company is still in business today in the Sellersville area.

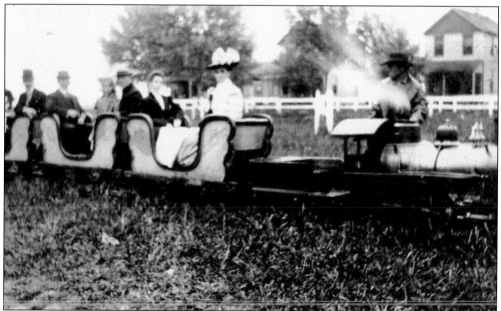

The Scenic Railway was a small gauge railroad, powered by a miniature steam engine. It was ironic that many parkgoers had to travel for miles via train and then trolley to arrive at the park, only to pay an additional fee to ride on this scaled-down train amusement. The homes in the background are those on Hillcrest Avenue, which was an established neighborhood prior to the park being built in 1898.

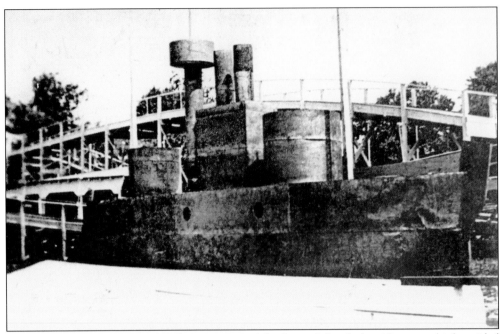

This photograph shows a scaled-down version of the Spanish battleship *Vizcaya*, which resided in the park's Whirlpool pond. The ship was part of the Spanish Fleet that was destroyed by the U.S. Navy at Santiago, Cuba, in 1898 during the Spanish-American War. This monument reflected the unabashed patriotism that was felt at that time.

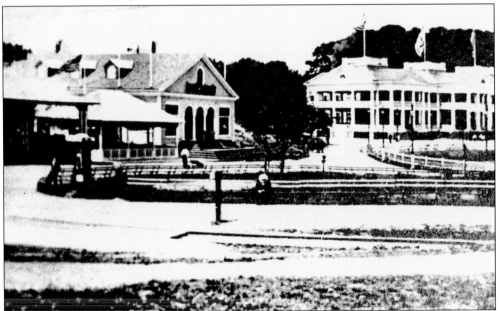

The park closed its doors after its final season in 1911. Today, no evidence of the amusement park remains, save for a small lake that was once home to the park's boat rental trade. Part of the property is now occupied by the Philadelphia Montgomery Christian Academy, housed in the former Hillcrest High School, with the remaining land serving as a township park that encompasses Hillcrest Pond.

Six

MANSIONS AND SUMMER RESIDENCES

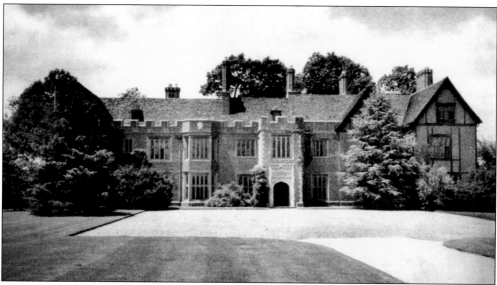

A visit to the Wharton Sinkler estate is to experience England in the Americas. Located at 631 East Gravers Lane in Wyndmoor, the house was built by Samuel B. Rotan, then district attorney of Philadelphia, in 1926–1928 on 40 acres. Rotan, a dedicated Anglophile, constructed a replica of an authentic English village. The manor house, which is modeled after Sutton Place in England (home of the duke of Sutherland, built in 1525), contains original rooms and materials brought over from England. The front doors are English oak from Muchelny Abby and were built in 739. The polished stone slabs in the front hall are from Warwick Priory, built in 1124. The house has gone by many names including Lane's End, Rotan Estate, and Guildford Estate. It was donated to University of Pennsylvania and served as the Wharton Sinker Conference Center. The university recently sold the manor house to a private owner, as well as all of the cottages on the property to individual owners.

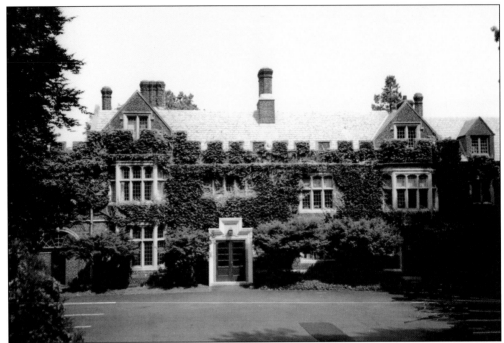

The mansion that stands on Willow Grove Avenue, between Sandy Hill Road and Falcon Drive, was once known as Falconcrest. Frederic and Marion Rosengarten built it in 1911 on land acquired from Marion's mother, Grace Sims. It was sold to Charles and Catherine Dickey in 1928, and they added an additional wing to the structure in 1933. The Dickeys owned the property until its sale to a developer in 1975. Since then, it has been the home of the Christian Counseling and Educational Foundation.

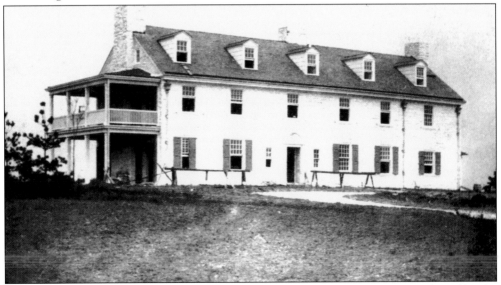

Little is known of this early farmhouse that was located on the property later purchased by the Newbold family, located off Willow Grove Avenue in the Laverock section of the township. Research of maps from 1893 and 1909 show that the Potts Farm Syndicate was the owner of the property and most likely constructed this home.

50

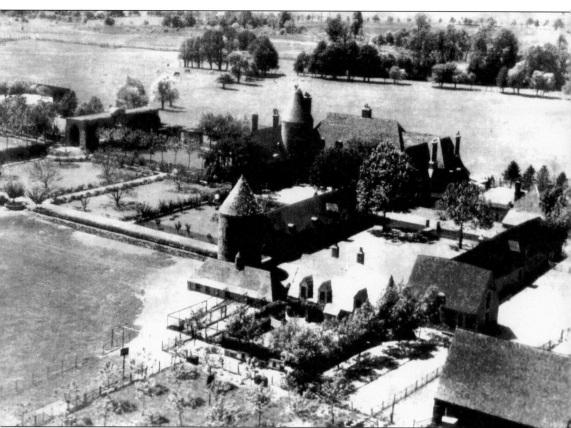

This aerial view shows the country estate of Arthur E. Newbold Jr., Esq. Known as Farleigh, the farm was located in the Laverock section of the township, with a portion of the property extending into Cheltenham. Much of the estate was designed and built by the architectural firm of Mellor, Meigs, & Howe in the early 1920s. Arthur was a partner in J.P. Morgan & Company and had inherited the estate from his father. All remnants of the estate are now gone, and the farm property, once famous for its fine cattle, was developed for residential use in the 1960s.

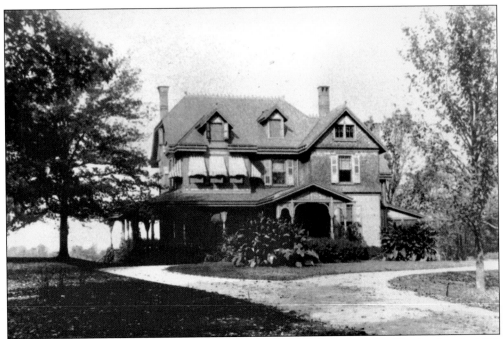

This beautifully landscaped Queen Anne Victorian cottage was built by Charles Lea in 1887 and named Rylston. Charles M. Lea (1853–1927) was a founder of Lea Brothers Publishers. His son Arthur would inherit this estate. Charles's father, Henry Charles Lea, was a famous historian of medieval Europe and wrote about the institutional and legal history of the Catholic Church. Much is documented about him in the University of Pennsylvania Library.

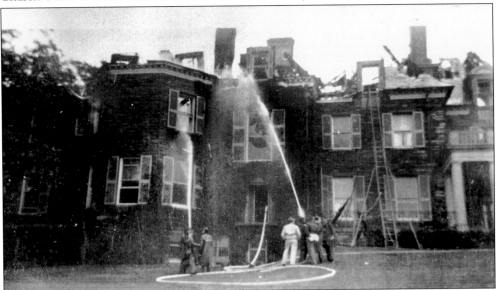

Through the years, Lea's Rylston residence underwent a complete metamorphosis to become an imposing stone mansion. Lea's estate was located at the north end of Gravers Lane in Wyndmoor, between the Stotesburys (Whitemarsh Hall) and the Rotans (Wharton Sinkler). In 1945, a fire gutted much of the Lea mansion, shown in this picture, and the home was later demolished in the 1960s.

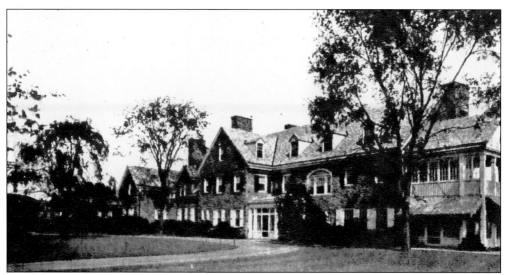

Here is a view of the Clarence M. Brown mansion, located on Cheltenham Avenue in the Laverock section. This estate was made up of two of the earliest parcels of land granted by William Penn in the Manor of Springfield. Brown purchased 27 acres from Louisa W. and John Strawbridge in 1927 for $47,500 and built his home, which he named Belcroft. Carl A. Ziegler designed the house. Brown's property abutted the Stotesburys and Newbolds. Brown added another 6-plus acres to his estate in 1927, with purchases from Edward Stotesbury, Benjamin Donahue, and the Enfield Association. When Brown died in 1958, his executors sold Belcroft, plus three tracts of land totaling 76 acres, to LaSalle College for $330,000, today the site of the La Salle College High School.

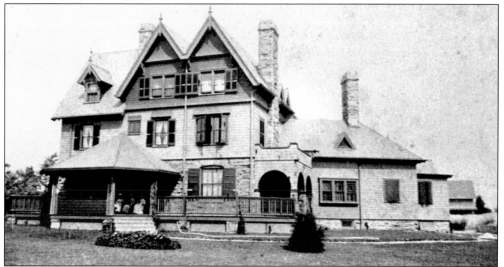

The arrival of trains in Chestnut Hill in the mid- to late 1800s fueled the building of many summer homes in the Wyndmoor area by wealthy Philadelphians. In 1882, Henry Neil Paul purchased 5.45 acres from the estate of Henry Guiterman and built this summer home at 546 East Graver's Lane a year later. In 1887, a second house was built on the property, and Elizabeth and Henry Paul sold this to their daughter-in-law, Margaret Butler Paul, wife of H.N. Paul Jr., for $5,000. The Paul family continued to occupy the original house until August 1991, when they sold both houses to the current owner.

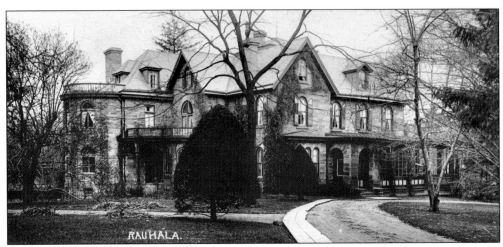

The estate once known as Rauhala is today the Keystone House at Wyndmoor, a hospice for terminal patients, located at 8765 Stenton Avenue. Clayton and Maria Platt sold the house in 1867 to John Welsh, who sold to Albert Kelsey in 1880. Kelsey, an architect and municipal planner, named the estate Rauhala and occupied the home until 1931. The house was restored by Keystone and today is listed on the National Register of Historic Places.

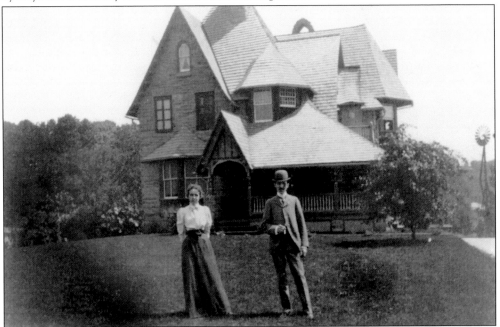

This picture shows Emma Yeakle Miller and an unknown man in front of the Yeakle Miller house, c. 1893. Emma was the daughter of Daniel Yeakle and married John Faber Miller, who was a noted judge in the Montgomery County courts. Yeakle owned 80 acres on the east side of Bethlehem Pike in Erdenheim. Being aged and seeing the development of the area as imminent, Yeakle sold all but 2 acres where he and his son-in-law would build identical Queen Anne Victorian homes for themselves. They built these homes at 500 and 502 Bethlehem Pike in 1892. Miller's property also consisted of a carriage house, which was located at 9 Hillcrest Avenue. Both of these properties remain today and are listed on the National Register of Historic Places.

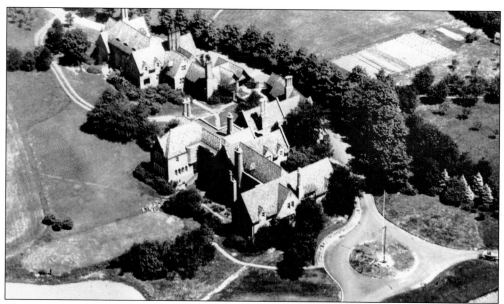

The buildings and cottages of the Carson Valley estate, shown here, are now part of the Carson Valley School, a facility for dependent or neglected boys and girls. The school was founded in 1907 as the Carson College for Orphan Girls in Flourtown. Robert N. Carson, a childless Philadelphia Traction Company magnate who provided $5 million to establish the school, built it on 105 acres. The school was a pioneer in social and educational reforms and was praised as the first orphanage in America, perhaps the world, to employ advanced social theory in its architecture. The architect, Albert Kelsey, designed an English hamlet for the buildings and grounds. The first structure, Stork Hill Cottage, was built in 1918. Additional cottages were eventually built, including Red Gables, Thistle, Upper Beech, Lower Beech, and South Fields. The main administration building was named Mother Goose. Carson Valley School is listed on the National Register of Historic Places.

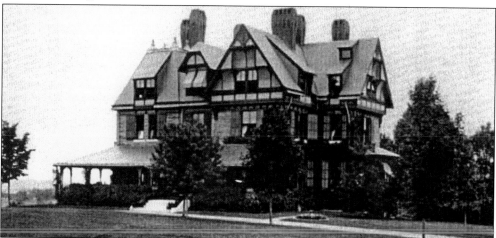

This English-looking house, named Hillbrow, was the residence of John Lowber Welsh. Built in the late 1800s, the home was located on Montgomery Avenue at the end of Birch Lane. Research of township maps from 1893 shows Welsh owning 155 acres of land that bordered Paper Mill Road and Montgomery Avenue. Welsh was a Philadelphia merchant who married Maria Newbold and died in 1904.

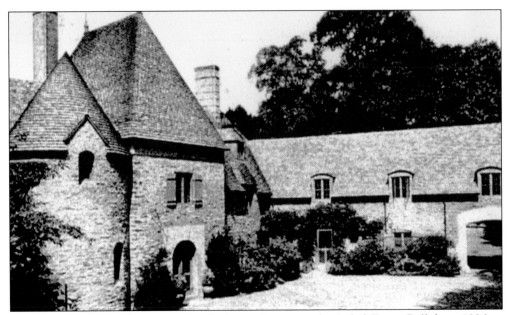

This French provincial mansion was built on three acres by Isabel Frazer Bell from 1926 to 1928. Located in Erdenheim at 8625 Montgomery Avenue, across from the Graystock estate, the home is constructed of stone and steel with a handmade tile roof. Both the Bell mansion and Graystock are still used as private residences.

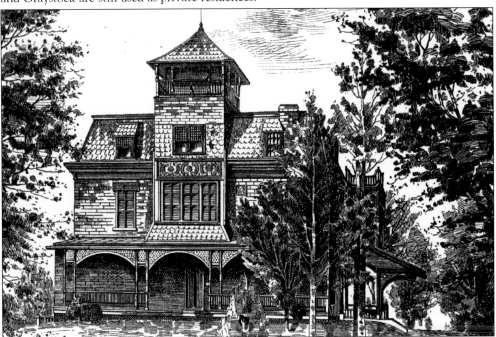

Graystock was once the countryseat of George C. Thomas. The house is still located at 570 Evergreen Avenue in Wyndmoor and was built by Clayton Platt in 1861. Platt sold the property to Joseph H. Dulles, who then sold it to Thomas in 1881. Thomas later hired architects George and William Hewitt to design the front tower seen in this picture. The Wilson Brothers and Company was later engaged to design the additions to the back of the house.

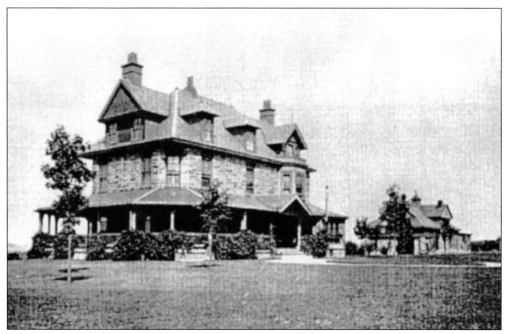

Stevenson Crothers built the Roslyn Heights Stock Farm *c.* 1886 on 64 acres of land that fronted Paper Mill Road in Erdenheim. Crothers died in 1935, and both the main home and carriage house (shown to the right) have been beautifully maintained to present day.

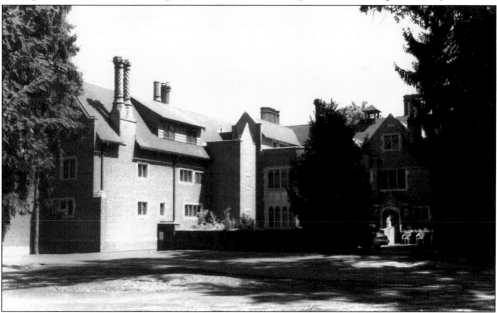

In 1910, Henry Frazer Harris built this 30-room English Tudor mansion, named Harston, on his 100-acre property off Haws Lane in Erdenheim. The mansion was both impressive and unusual, with the exterior stonewalls 37 inches thick and with a design that included numerous hidden stairways, rooms, and vaults. Harris closed up Harston in the late 1940s and lived out his days on his yacht. In 1951, Harris died and the estate was sold to become a housing development, with the mansion being converted into a convalescent home, which it still is today.

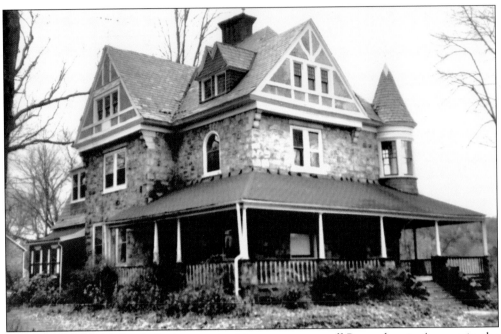

As far back as 1894, Jacob Rech owned a 16-acre property off Pennsylvania Avenue in the Oreland section of the township. In addition to this land, Rech, along with George Apel, owned a 116-acre tract of land that was later used to develop the White City section of Oreland. Rech named his stone house and property Linden Lawn. By 1949, it had become the property of Dr. J. Mervin Rosenberger, who would be responsible for the renovation of the Emlen farmhouse and donating the land where Christ's Lutheran Church now stands.

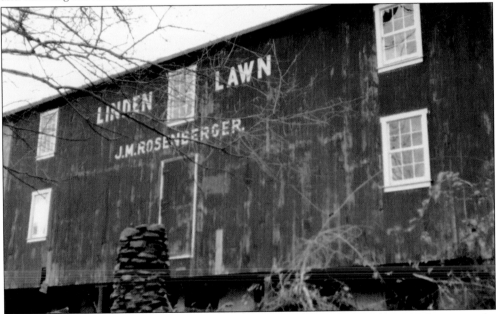

This barn, once part of the Linden Lawn estate of Dr. J.M. Rosenberger, was torn down to make room for the development of residential homes on Rech Circle off Pennsylvania Avenue. The main house is still standing and also used as a residential property.

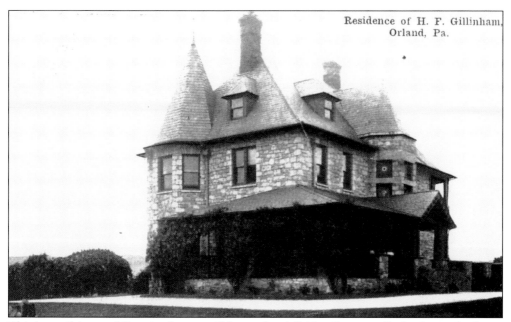

This beautiful stone Victorian home, still located at 1 Bridge Street in Oreland, was the home of H.F. Gillinham when this picture was taken in 1922. Earliest research shows that Jacob Rech owned the land in 1893. Rech owned large tracts of land in the Oreland section of the township. Gillinham most likely purchased the ground from Rech to build his residence.

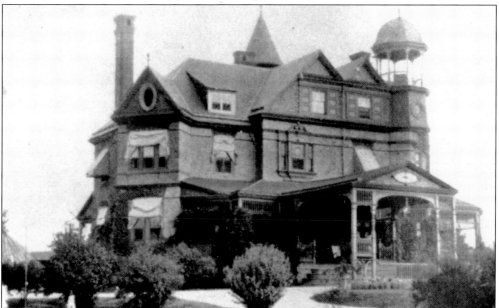

In 1742, Nicholas Scull sold to Lynford Lardner a portion of farmland in the Oreland section of the township. By 1883, this 108-acre property on Valley Green Road, between Walnut Avenue and Bridle Lane, was sold by Jonathan Shaffer to Alexander Ralph for $24,000. Irene DuPont Hendrickson Ralph, the son of Alexander, was to later become the owner of Arlington, and the estate remained in the Ralph family until 1923, when it was sold to the Edge Hill Golf Club for $115,000.

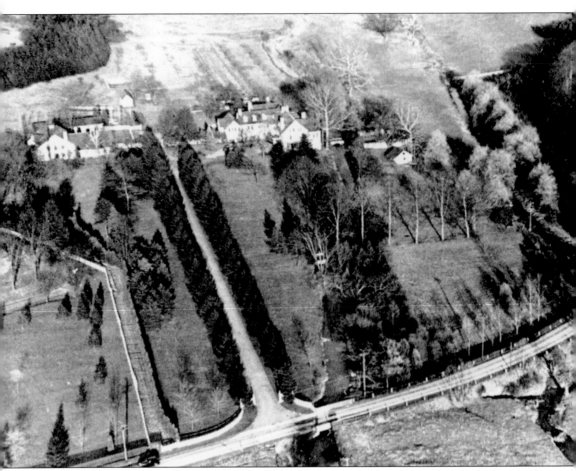

This photograph is an aerial view of the Emlen House, located on Pennsylvania Avenue at the base of Camp Hill. Built c. 1750 by George Emlen, it is best remembered as the headquarters for George Washington between October 30 and December 11, 1777, prior to marching on to winter quarters at Valley Forge. Emlen was a prosperous Quaker merchant from Philadelphia. He and his brother, Caleb, were partners in a wine importing business, and they shared the use of the country house for vacations away from the city. George Emlen died on January 3, 1776, and the house at the time of the encampment was owned by Emlen's widow and was occupied by his son and family. Additions and improvements have been made to the house over the years, but the outline of the original mansion can still be traced. Edward Piszek, who bought the house and the 34-acre property from Radcliffe Cheston in 1956, now owns the estate. Mr. Piszek was the founder of Mrs. Paul's Kitchens, a trailblazer in the frozen-food industry, and later founder of the Copernicus Society of America.

Seven

WHITEMARSH HALL

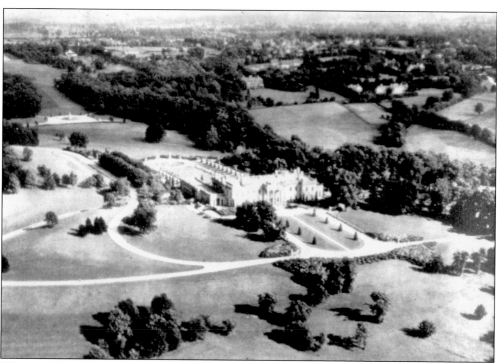

Whitemarsh Hall, once called the Versailles of America, was the magnificent estate of Edward and Eva Stotesbury. The mansion was situated on approximately 325 acres and composed of multiple properties. The estate was protected by an 8-foot-high wrought-iron fence that ran for two miles around the property. The fence was donated in the 1940s for meltdown and material use in the war effort. The main entrance on Willow Grove Avenue actually faced the back of the house, over a mile away. The road was not straight but wound around through the property, coming up along Maple Alley, in the left-hand side of the picture, and curving around to the front entranceway. The house faced onto Paper Mill Road and had a tremendous view of the Whitemarsh Valley. The town of Wyndmoor is in the distance, on the upper right-hand side of this picture.

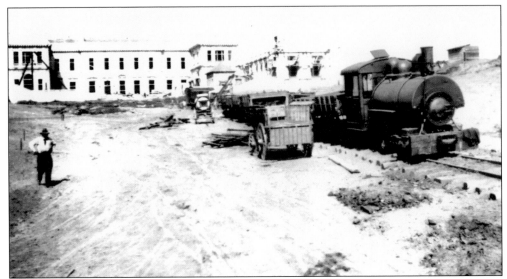

Groundbreaking began on October 20, 1916, by the George A. Fuller Company. Almost five years later, the house was officially opened to society on the afternoon of Saturday, October 8, 1921. The house alone cost about $3 million to construct and landscape, and the interior finishing work and decorating cost several million more, including a world-class art collection. There were six stories to this Georgian mansion, with three below ground and three above. Horace Trumbauer was the architect of this masterpiece, which included 147 rooms, 45 bathrooms, a 64-foot long ballroom, a gymnasium, a movie theater, a three-story pipe organ, three elevators, and its own phone switchboard linking the outside cottages on the estate. Three separate doors guarded the wine cellar, which was well stocked, even during Prohibition.

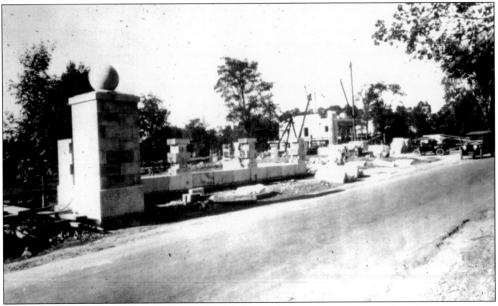

The main gates on Willow Grove Avenue and the gatehouse were constructed at the same time as the main house. All of the structures seen in this picture still exist today. There were other entrances that led up to the main house, including ones off Cheltenham Avenue and Paper Mill Road. Both entranceways still exist today at 8810 Cheltenham Avenue and 930 Paper Mill Road.

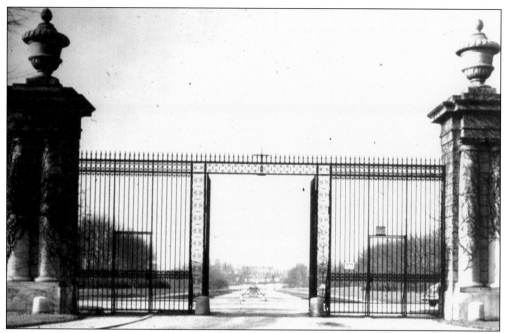

Most guests arrived by train, debarking at the Wyndmoor Station about a mile away, and were driven by private limousine through these gates on Willow Grove Avenue. The main house, Whitemarsh Hall, could be seen from about a mile away in the distance. Today, the iron gates are gone, but the majestic, 50-foot-high pillars still remain.

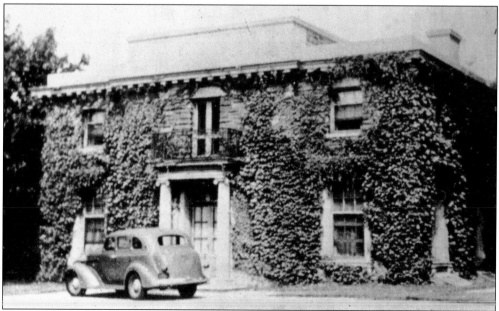

This was the gatehouse for the main entrance off Willow Grove Avenue as it was in 1938. The two-story structure was built of the same materials as the main house, with an Indiana limestone skin. When Mr. Stotesbury's limousine passed through the gates and by the gatehouse, the organ in the main house would begin playing his favorite tune "The End of a Perfect Day." Today, this house is privately owned and has been magnificently restored by its present owner.

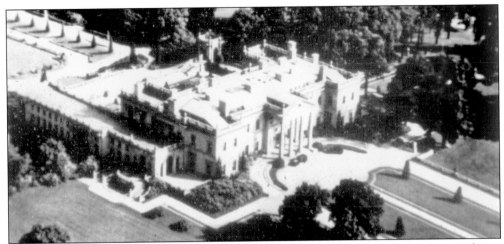

This picture and the next one of the rear of the mansion were taken in the mid-1930s for an article in *Fortune* magazine. The Stotesbury's living quarters were on the second floor, on the right-hand side of this picture. Four main guest rooms, each a different color and theme, were situated in the middle of the second floor. The servant's quarters were on the third floor, mostly hidden from view by the balustrade.

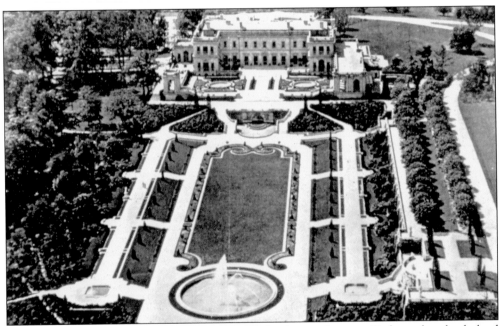

The formal gardens were the creation of French landscaper Jacques Greber, who also helped design the Benjamin Franklin Parkway in Philadelphia. All plantings and trees were brought in and planted fully mature, including the maple trees that formed Maple Alley, which were brought one by one on flatbed truck up Broad Street in Philadelphia to the mansion. The estate cost an estimated $1 million per year to maintain, and required 70 full-time gardeners. It was considered one of the best-kept estates in both America and Europe. Despite the cost, the Stotesburys lived there only in the spring and fall. After Mr. Stotesbury's death on May 16, 1938, Mrs. Stotesbury put Whitemarsh Hall up for sale and moved to El Mirasol, where she passed away on May 26, 1946.

Pictured from left to right are Jimmy Cromwell (Eva's son), Will Rodgers, Lucretia (Eva) Stotesbury, and Edward Townsend Stotesbury standing under the front portico of Whitemarsh Hall. Many famous and powerful guests from business, political, and social circles visited this home during its life (1921–1938). Visitors included crown prince of Sweden, Gen. Douglas MacArthur, and several United States presidents. It was Henry Ford who reputedly commented after his visit, "It was a great experience to see how the rich live." Edward Stotesbury, born and raised in Philadelphia, was a self-made man. At his wealthiest, he was worth an estimated $100 million, which dwindled to about $4 million at the time of his death.

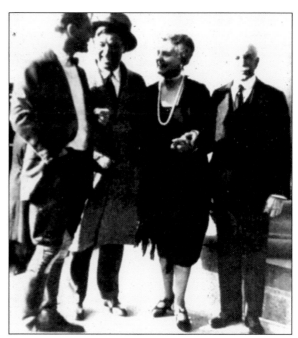

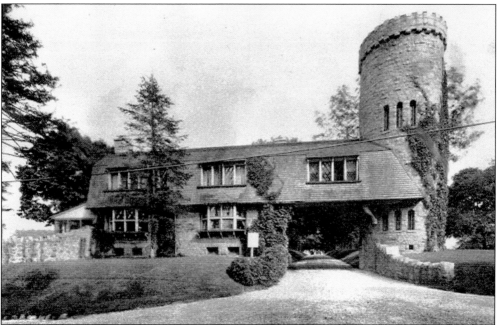

One of the exits from the Whitemarsh Hall estate was through this turreted gatehouse on Paper Mill Road. This was once the main entrance into the Robert Grant Fell estate and was purchased by Edward T. Stotesbury from Fell for his Whitemarsh Hall property. The home is estimated to have been built between 1893 and 1897. The main part was used as servant's quarters, with an attached four-story stone tower that housed the groundskeepers. The entrance door to the tower is several feet off the ground, so that the gatekeeper could open incoming carriage doors and greet and identify their guests. Stotesbury retained this unique home as a service entrance. Today, this is a private residence at 930 Paper Mill Road.

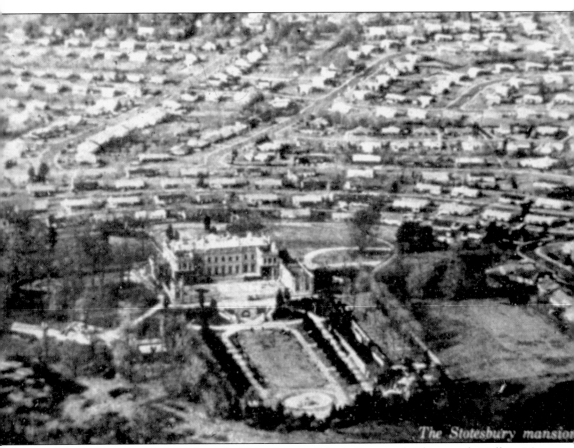

The Stotesbury mansion

Edward Stotesbury's funeral was held in the candlelit ballroom of Whitemarsh Hall in May 1938. It was to be the last formal event ever held at the mansion. Although Eva was willed the lifetime use of the estate, there was not enough money left to maintain it, so she put it up for sale and moved south. A skeleton staff was left behind to maintain the house and property until it was sold to the Pennsylvania Salt Company in 1946. The Pennsylvania Salt Company was a chemical company that used the house for a research laboratory and offices until its departure to King of Prussia in 1964. It sold the mansion and remaining property to a developer in 1965; unfortunately, nothing came of the many different plans to save the great estate. This picture from 1968 shows the post–World War II development that encroached almost to the mansion's front door. The grounds between the main gate at Willow Grove Avenue and the mansion's formal gardens had been developed in the 1950s and 1960s into a housing development named Whitemarsh Village. After years of vandalism and fires, the mansion finally fell to the wrecking ball in the spring of 1980. Today, a tasteful sign, simply reading "Stotesbury," identifies the entranceway to a townhouse complex around the site of the mansion. The actual ground where the mansion stood has not been built on, and some remnants remain of the former glory, including the entranceway pillars used to hold up the portico where so many famous people came to see and to be seen between 1921 and 1938.

Eight

Pre–World War II Urban Development

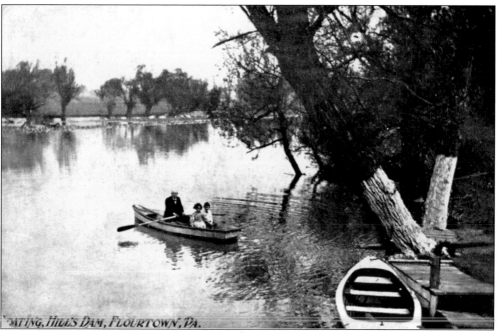

Erastus Hill owned the Cedars, a 100-acre estate, including a large pond, which was created by damming the Wissahickon Creek. This was located off Bethlehem Pike, on the border of Flourtown and the township, with the head of the pond at the end of a private road (west of the Pike), across from Valley Green Road. The road still remains today but terminates at the Wissahickon Creek, where it appears a bridge once existed.

In the late 1600s, settlers began enlarging a Native American trail that ran northward from the Delaware River through Springfield. The trail was known as the King's Highway or the Bethlehem Road. In 1698, the surveyor general of Pennsylvania petitioned for a road connecting the limekilns at Wide Marsh (Whitemarsh) with Philadelphia, and the road was opened in 1703. At one point, the road stretched from Chestnut Hill to Bethlehem, a distance of 43 miles. This view is looking south down the Pike towards Erdenheim and the intersection at Mill Road. The Springfield Inn is on the left.

Here is a view of Springfield Avenue looking out to Bethlehem Pike. On the right is the Springfield Hotel (on the present-day building, the upper multiwindowed room has been removed), now named the Sorrella Rose Bar and Grille. The building on the left was once the Flourtown Post Office, which was torn down to make way for Gino's Restaurant. The water tower in the near distance, across the street, served the Reading Railroad line. The empty field immediately across the street is now home to the Flourtown Commons complex, housing multiple businesses.

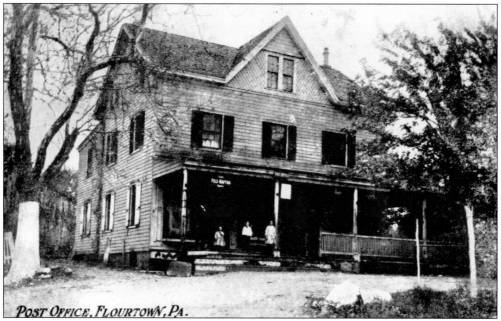

POST OFFICE, FLOURTOWN, PA.

A post office was established in Flourtown before 1810, when Nicholas Kline was postmaster, and was located at Kline's Hotel until 1826, when it was moved up to Whitemarsh. Upon its return to Flourtown in 1875, it was established at Yeakle's Store, and Joseph Yeakle was postmaster. The store was located next to the Springfield Hotel on the corner of Bethlehem Pike and Springfield Avenue.

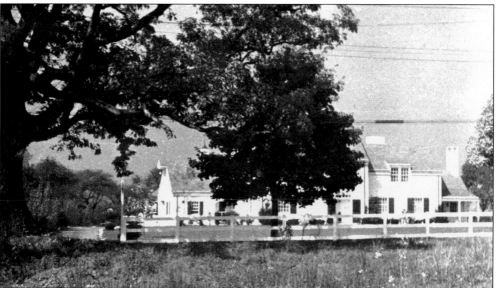

This photograph shows the historic Penn Oak home in 1938, across the street from Robert and Edythe Weavers's home at 107 East Mill Road in Flourtown. This large seven-bedroom Colonial was located on 2.9 acres and exited onto Springfield Avenue. The house also had six baths, three fireplaces, and a three-car garage. Developed with rooms for live-in help, it was an example of the larger homes being built in certain areas of the township at this time. The home is beautifully maintained today as a private residence.

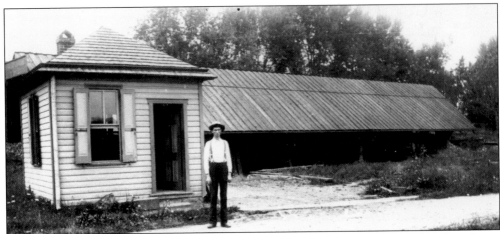

Robert McCloskey built this coal yard on the north side of the Reading Railroad tracks on Bethlehem Pike. This was opposite the coal yard that he had leased from George Seckler in the 1880s. This picture shows what was Flourtown's first library building, with McCloskey's coal yard in the background. The photograph was taken from East Mill Road looking north, with Bethlehem Pike on the left.

Shortly after the North Pennsylvania Railroad (later the Reading Railroad) established a station at Flourtown, George Seckler built this coal yard on the south side of East Mill Road and Bethlehem Pike. It was leased from Seckler by Edward McCloskey in 1880 and later taken over by the Comly family. Shown here in the 1940s, the yard went out of business in the 1950s. Today, this property is the location for the Amoco gas station.

What is today the Acme Shopping Center on Bethlehem Pike at the corner of East Mill Road was once part of the Comly Coal Yard. The Comly family home is shown in the background facing Bethlehem Pike. This house was originally an inn run by Christopher Mason and built *c.* 1742.

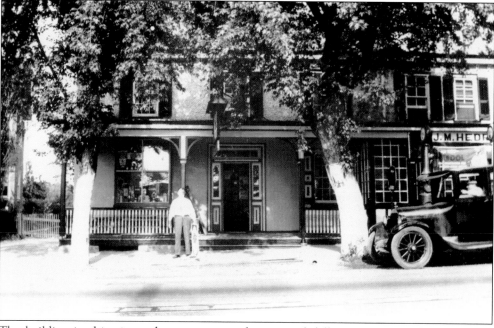

The building in this picture has seen many changes and different uses over the years. It is located at 1538–1540 Bethlehem Pike, between the Acme Shopping Center and Mt. Airy Auto Parts and today is the home of Cisco's Bar and Springfield Insurance & Financial Services. The house was built *c.* 1873. In 1887, John M. Hedrick opened a saddler and harness shop in the building, which he ran for over 35 years. Hedrick was for many years a justice of the peace in the township.

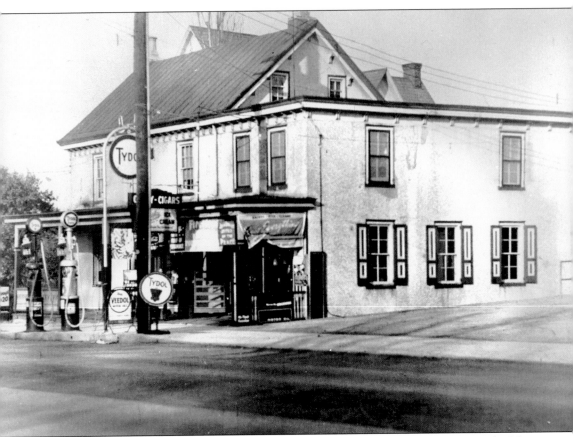

By 1934, when this photograph was taken, the building in the previous picture had been converted to a service station. Notice that the gas pumps are right on the curb, allowing automobiles to pull up to be serviced. In 1956, William Gerstlauer sold this property to James and Ann Ciaccio, who established Cisco's Bar. How times have changed.

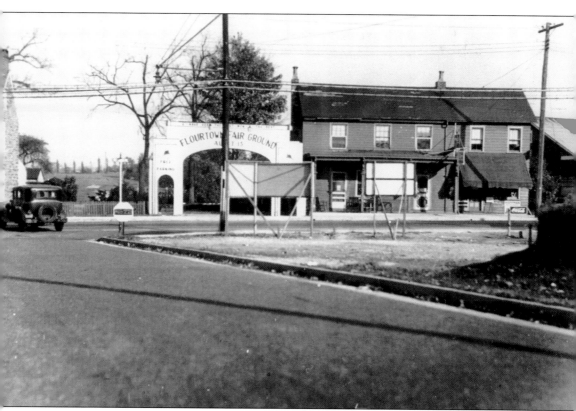

The Flourtown Fair was started in the mid-1930s and was a great fundraiser for the Flourtown Fire Company until 1952. This picture shows Grove Avenue in the foreground. The house to the left of the fairground entrance was torn down to make room for the current fire company building. The buildings to the right of the entrance are still standing, with multiple businesses occupying them. The house on the right side of picture is gone. The entrance to fairgrounds is now the entrance to the Flourtown Swim Club.

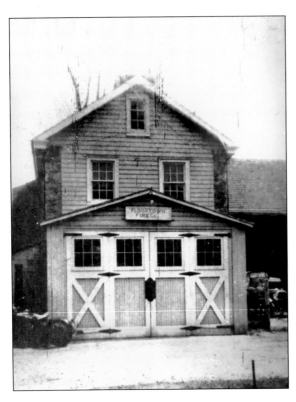

In 1910, a group of citizens established the Flourtown Volunteer Fire Company and for years served the needs of the community with one hand-drawn hose cart that was housed in this barn, shown here in a 1929 photograph. Today, the company operates from the modern firehouse, located on Bethlehem Pike, which was built in 1967.

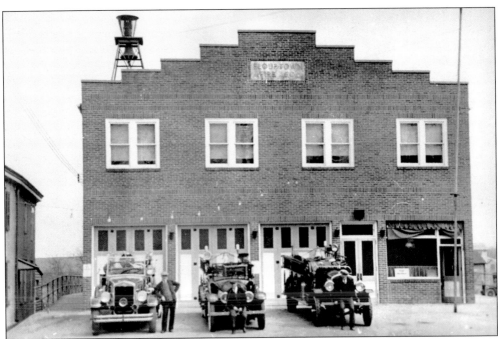

A picture from 1936 shows the second location of the Flourtown Fire Company, 1528 Bethlehem Pike. The present firehouse would later be built to the right of this building. Notice the door and glass window, leading to the Flourtown Post Office, on the right side of the building.

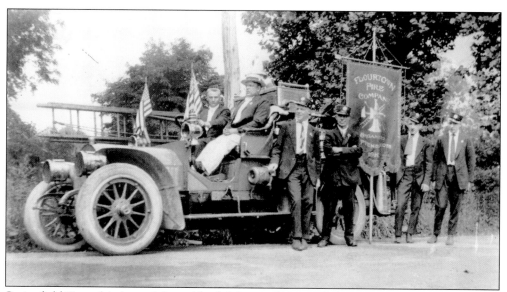

Springfield Township has celebrated both Memorial Day and the Fourth of July for years with parades in Wyndmoor and Oreland. Here are members of the Flourtown Fire Company in 1910 displaying one of their engines at the summer parade.

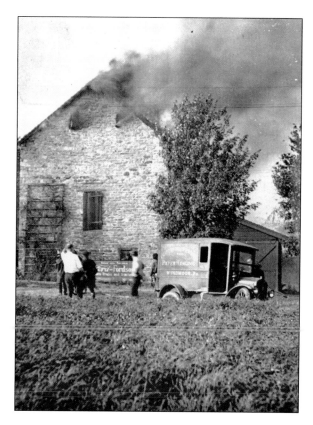

The cause of this barn fire in 1924 remained a mystery to local residents. The barn was located at 3 Weiss Avenue in Flourtown and believed to be used by a local Ford dealership for storing their cars. The truck in the foreground belonged to Donofry & Sons Paper Hangers, established in 1890 and residing at that time at 1000 Willow Grove Avenue. The walls of the barn were left standing for many years after the fire, and it was later converted into a house, which stands at 3 Weiss Avenue.

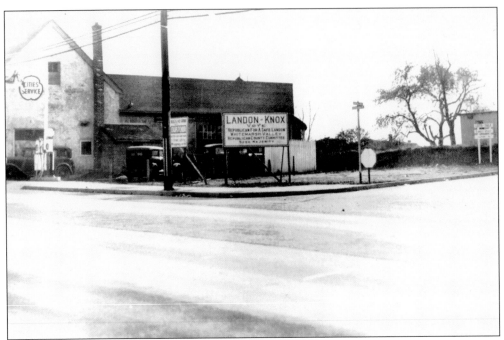

When this photograph was taken in 1936, Republican Gov. Alfred Mossman Landon of Kansas was running against Franklin D. Roosevelt, who was seeking his second term as president. Landon was defeated in a landslide by Roosevelt, winning only two states. The location of this campaign sign is at the corner of Bethlehem Pike and Grove Avenue.

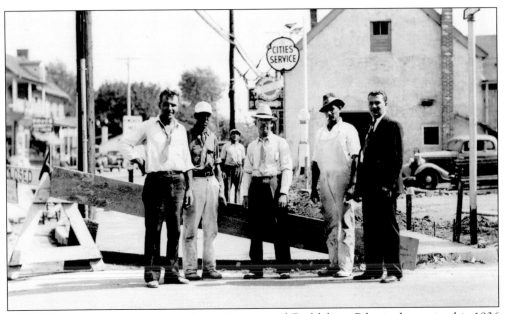

Installation of the curbing along Grove Avenue and Bethlehem Pike is shown in this 1936 photograph. The man in the center was Elmer "Dynamite" Perry, township commissioner, who worked in the explosives business.

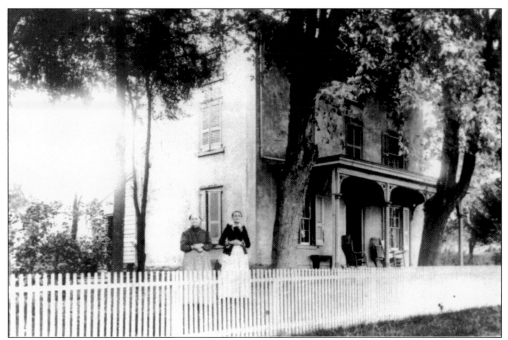

This house stood at 1448 Bethlehem Pike, near the corner of Bysher Avenue on property that was once part of the Black Horse Inn tract, and was built between 1820 and 1826. It was later called the Marigold Cottage, a name it received when the Carson Valley School rented it. A Miss Scott ran an antique store out of the house in the 1960s and 1970s. It was demolished in 1987 to make room for a state liquor store and parking lot.

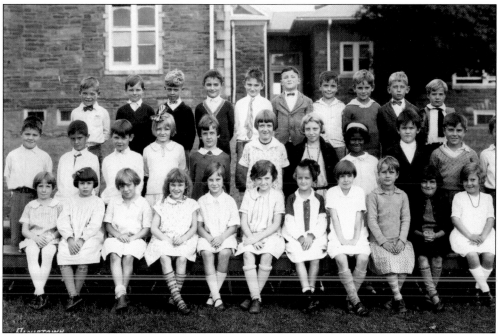

Here is a group of fifth-grade schoolchildren in 1928 in back of the Flourtown School on Wissahickon Avenue. The school was built in 1879 with additions made in 1907 and 1921.

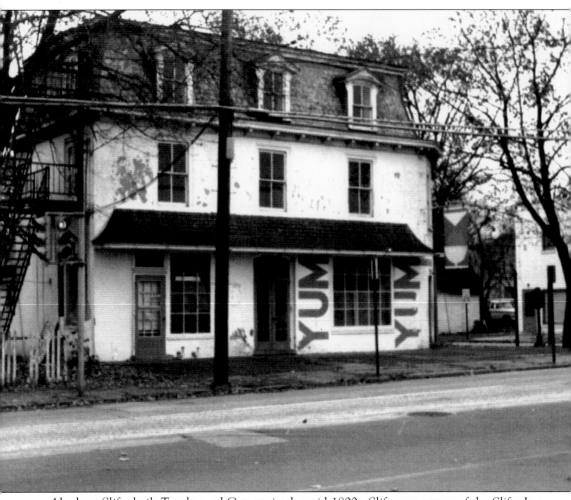

Abraham Slifer built Tanglewood Cottage in the mid-1800s. Slifer was owner of the Slifer Inn (also known as the Eagle Hotel) for 40 years until his death in 1875. Tanglewood Cottage was rented in the 1920s by Carson Valley School as a dormitory for part of its female population while the buildings on the campus were being constructed. Pictured here as the Yum Yum shop in 1974, it served in this capacity for a number of years. This Victorian building was later torn down to accommodate Friendly's restaurant. Today, it serves as a Starbucks Coffee shop in front and a Roxborough Manayunk Bank branch in rear.

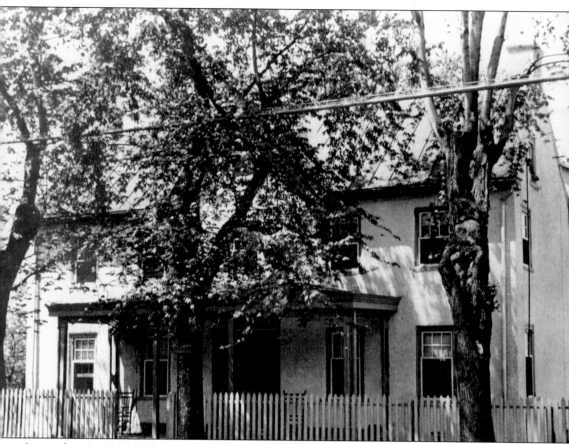

Located at 1419 Bethlehem Pike and currently part of Carson Valley Estate, this house was built c. 1747 by William Parson, who bought the original 21.5 acres from Reynor Tyson. George Lower later purchased the house for $4,800. Lower, who was born in Springfield, formed a military group in the 1840s at age 19 to suppress riots in Philadelphia. He later went with his brother to fight in the Mexican War, where his brother died. He returned to Springfield and purchased this property in 1858. He died in 1904, leaving the estate to his wife. In 1909, the property was bought by John Goss and then purchased by the Carson School in 1918 for about $12,000. William "Bill" Goss, who grew up in the house, worked at Carson as head of maintenance for over three decades.

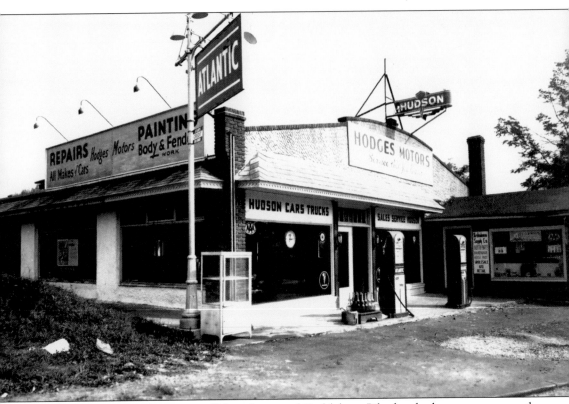

This structure on the corner of Haws Lane and Bethlehem Pike has had many uses over the years. Although the building may have been built prior to the 1930s, the earliest known deed goes back to 1931, when it operated as the Erdenheim Garage. It was bought by Franklin and Violet Hodges in 1945 and was Hodges Motors until 1951, when it was converted to a bowling alley. Since 1971, it has operated as a car wash.

This was the home of Patrick Sheehan, located at 709 Bethlehem Pike in Erdenheim. Sheehan was a blacksmith for more than 38 years; he served as one of Springfield Township's first commissioners and had the distinction of being the board's first president. This home was built in 1867 and sold to Sheehan in 1883 for $1200, which included the house and three acres. Today, C&H Insurance occupies the house.

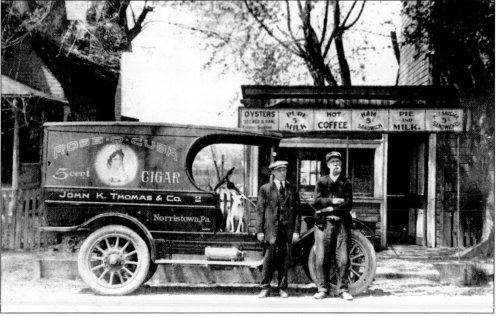

This store was located at the corner of Montgomery Avenue and Bethlehem Pike in Erdenheim and is pictured c. 1916. The shop served both local villagers as well as those traveling into the area by horse and rail. The Lehigh Valley Traction Company's trolley line ran right by this establishment, dropping people off for the Chestnut Hill Amusement Park across the street until 1911.

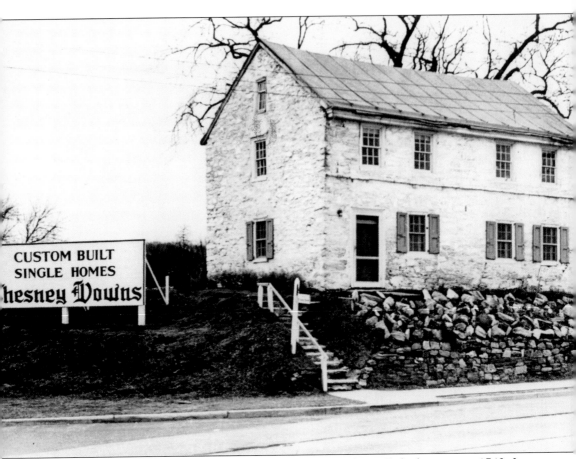

CUSTOM BUILT
SINGLE HOMES
hesney Downs

The Ottinger house has been a fixture on Bethlehem Pike in Erdenheim since 1743. It was already 200 years old when this picture was taken, showing the announcement of the Chesney Downs development in the 1940s. This was one of the first major housing developments to occur in the township. Today, this area contains some of Erdenheim's most desirable homes. The Ottinger house, which has been beautifully restored since the time of this photograph, still stands as a witness to history.

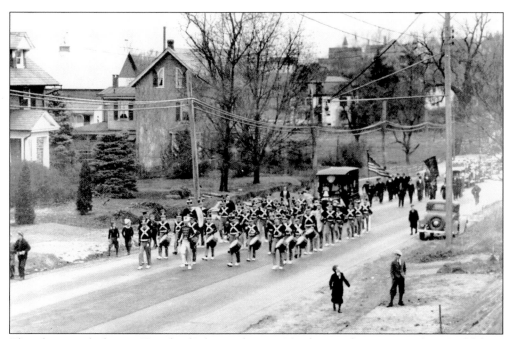

This photograph shows a Fourth of July parade in 1935. The parade route was along Bethlehem Pike, and this picture was taken from near the Ottinger house (see the previous page), looking north.

This picture was taken from Montgomery Avenue where it terminates at Bethlehem Pike. The front of this home was extended to house different businesses, including the present-day picture framing company. Here, Bethlehem Pike is still a dirt road and the lack of trolley tracks indicates that the photograph was taken before 1900. The boy in this photograph is Walter Scott, one of the attendants in the Grand Casino of the White City amusement park.

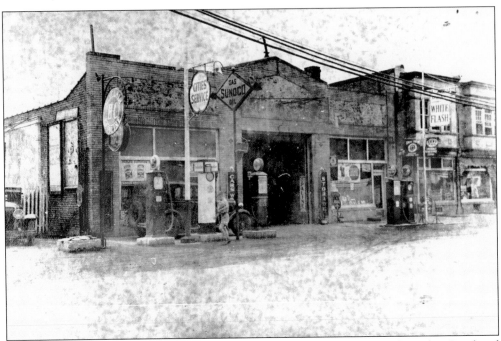

In 1932, the Keystone Garage was located in this building at the corner of Gordon Road and Bethlehem Pike. It has served as a garage through the present day with the current owners being the Morano Brothers. The buildings to the right are still used as commercial properties.

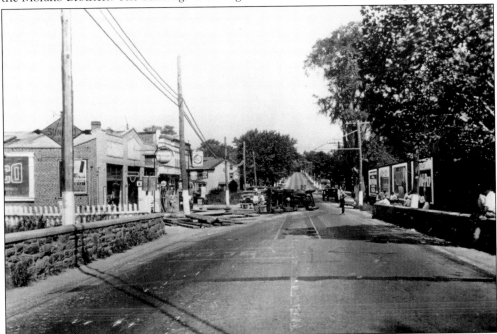

An accident on Bethlehem Pike is shown in a view looking north towards Flourtown from Erdenheim. The stonewalls in the foreground of this picture indicate the overpass where Paper Mill Run flows under Bethlehem Pike from Hillcrest Pond, not easily noticeable today. The building on the left past the stonewall is currently Morano's Garage.

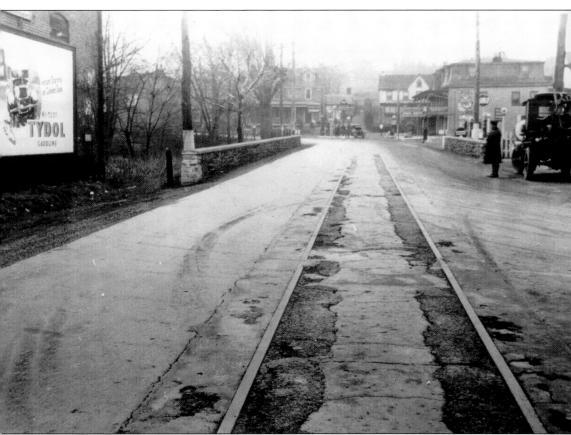

Here is a photograph from the 1920s looking south on Bethlehem Pike towards the Wheel Pump (shown in the upper right corner). Notice the trolley lines in the road. The Lehigh Valley Transit Company ran a Bethlehem to Erdenheim line on the Pike until 1926. The tracks were removed in 1960 as part of a sewer-replacement project.

This 1922 house was the first to be built on Gordon Road. It was built for the John Henry Boyd family. Boyd, his wife (Isabel Fenn), and children (Johnny, Muriel, Florence, and Edith) came from Neury, Ireland, to America in 1912. John rented land to farm in the area of Gordon Road and Bethlehem Pike. The children attended the Flourtown School located on Wissahickon Avenue. This house exists today as 20 Gordon Road.

This home is located on the east side of Bethlehem Pike between the Heydrick house and Hillcrest Avenue. It was once owned by Charles Streeper, who also owned several houses and properties in Erdenheim and Flourtown, including a tract of land where Tanglewood would later stand. His daughter Edna purchased a home, located at 410 Bethlehem Pike in Erdenheim, in 1953 from Charles and Muriel Guenst, maternal grandparents of the authors. This picture was taken c. 1912, when the house had no running water or electricity.

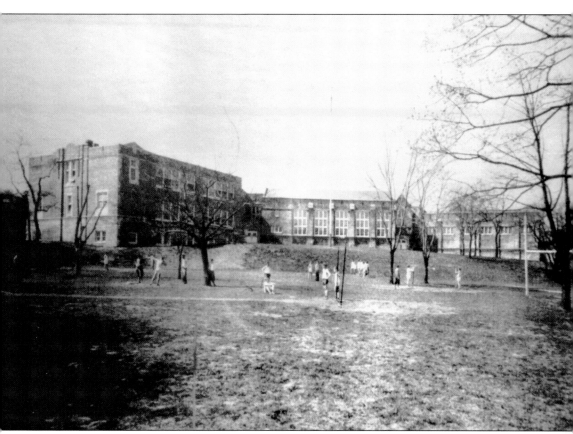

Springfield Township voted to pass a bond issue in 1922 to raise funds to build the first township high school, named Hillcrest. This was to be built on the land of the former Chestnut Hill Amusement Park. The building project was completed by 1924, and it included 12 classrooms, a gymnasium, an auditorium, and a cafeteria. It would house both junior and senior high school grades. Through the years, there would be expansions of the original building, and these can be clearly seen today on the exterior of the building. In 1930, six classrooms were added, along with a library, a new cafeteria, and administrative offices. The junior high gymnasium was added in 1939 as one of the Works Progress Administration's projects. The year 1948 saw the addition of a student activities room, additional classrooms, and an enlarged cafeteria. Today, Philmont Academy occupies this building, and the rest of the grounds of the former Chestnut Hill Amusement Park are home to the James A. Cisco Park and the township school bus garage.

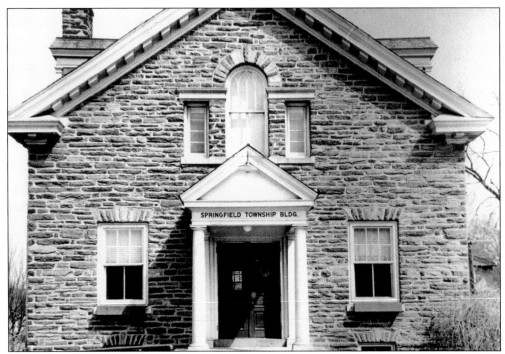

In 1907, Springfield built the first municipal building at a cost of $12,000. It was located at 402 Bethlehem Pike, between Bells Mills Road and Hillcrest Avenue. The first commissioners' meeting was held here on March 4, 1908. Today, the building is named the Bell Building and houses the Three Marketers marketing firm.

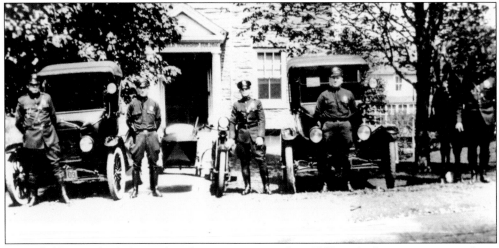

Springfield Township's first police force was organized in 1903 with the appointment of two patrolmen and was known as the Night Watch and Police Force. By the 1920s, the police force had significantly grown and utilized horses, motorcycles (complete with sidecars), and a fleet of two automobiles. This picture was taken in front of the old township administration building at 402 Bethlehem Pike in Erdenheim.

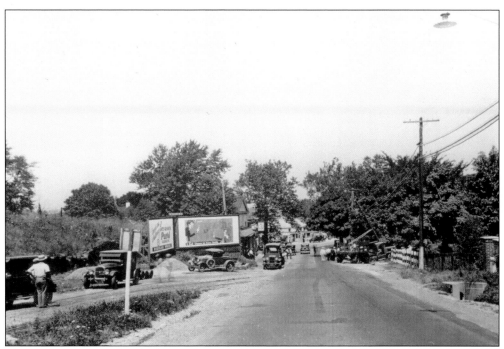

This picture from 1927 is looking north on Bethlehem Pike from Stenton Avenue. The Wheel Pump Inn is visible in the background at the bottom of the hill. Notice the billboards on the left side. Other photographs from this period show billboards up and down the Pike in the Erdenheim section.

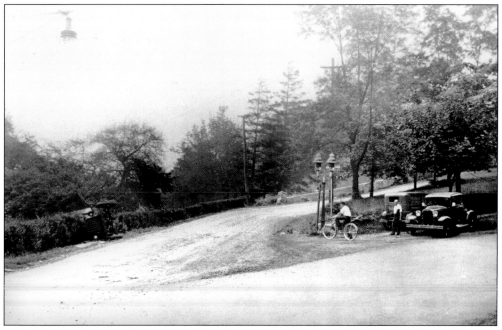

This picture of yet another car accident shows an early view of the intersection of Stenton Avenue and Bethlehem Pike. From the 1800s to 1904, this was the location of a tollhouse and gate for the North Wales Great Road.

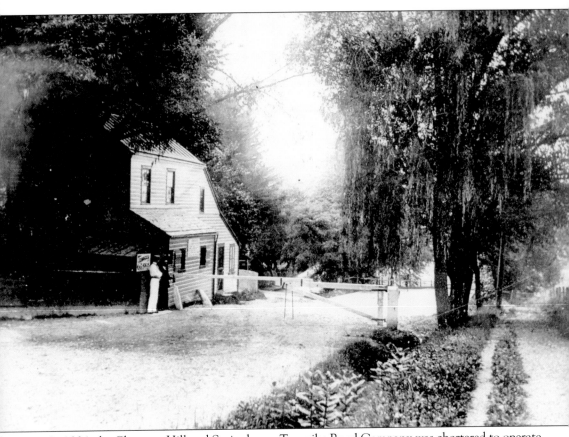

In 1804, the Chestnut Hill and Springhouse Turnpike Road Company was chartered to operate the road, which was then called the North Wales Great Road. This tollgate was located at the present intersection of Bethlehem Pike and Stenton Avenue and was in operation until 1904.

Located at 9425 Stenton Avenue was the Hillcrest Hotel. Built in 1916 and sitting on land purchased from the Penn family in 1715, it was named the Hillcrest Hotel in 1933. Prior to this time, it had been Otto's Grotto and was a reputed speakeasy during the Prohibition era. During the 1930s, the hotel housed the Philadelphia Eagles professional football team during the preseason, the practice fields being located on West Oak Lane and transportation being provided by the local Chestnut Hill Grocers van. The hotel served as a hospital during World War I and was later renamed Whitemarsh Valley House in 1962. The porches in this picture are gone, and four two-story columns have replaced the front portico. The building currently houses multiple businesses and apartments on the second floor.

Here is a car broken down on Stenton Avenue with a view of the Widener Farms in the background. The Widener estate, lying mainly in Whitemarsh Township, traces its origins to a small farm owned by a settler named Hocker *c.* 1849. It was later increased to 250 acres for breeding horses. In 1896, Robert Carson, who bequeathed some 50 acres to establish Carson College for Orphaned Girls, known today as Carson Valley School, bought the land.

DAM AT CLEAVERS MILL, FLOURTOWN, PA.

John Cleaver owned a flour and gristmill along the Wissahickon Creek, near the intersection of West Mill Road and Stenton Avenue in what is now Whitemarsh Township. The dam and resulting pond, which the creek flowed through, was on the east side of Stenton Avenue, which at the time was within the Springfield boundaries based on an 1893 map of the township.

This photograph was taken during a fox hunt in Springfield Township. The suburban areas around Philadelphia were considered some of the best fox hunting areas in America in the 1800s and early 1900s. The major population boom in the post–World War II era led to a great decrease in the fox population. Several hunt clubs existed in adjoining townships. It was common for farmers, along with their horses and hounds, to join in the chase with more experienced gentleman riders from the city.

The Wyndmoor Hose Company No. 1, established in 1907, was originally located at Mermaid Lane and Queen Street. In 1916, they moved the firehouse to Queen Street and then relocated in 1967 to the current station on Willow Grove Avenue. This picture was taken c. 1916 on Willow Grove Avenue and shows, from left to right, Jim Sullivan (chief engineer), Jimmy Boyle (chief from 1916 to 1917), two unknown men, Mr. Zeigler, and A.B. Kerper.

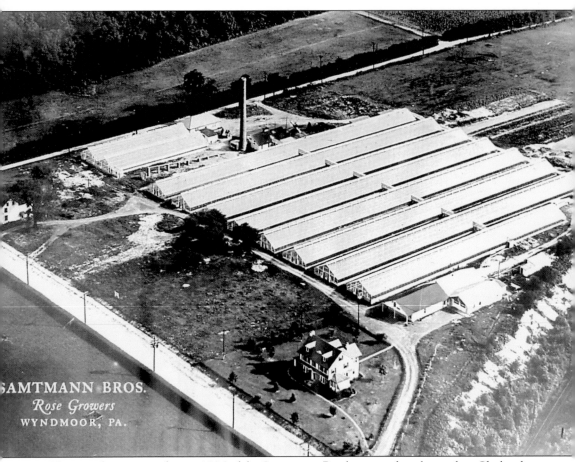

SAMTMANN BROS.
Rose Growers
WYNDMOOR, PA.

This aerial view was taken in 1926 of the Samtmann Brothers rose farm located on Cheltenham Avenue, between Ivy Hill Road and Mermaid Lane. This was a family business in operation from 1922 to 1973, when rising fuel costs forced them to shut down. Wyndmoor was a principal area for rose growing in America between 1870 and 1960. Three families were involved at that time, the Samtmann, John Burton, and Frank Myers families. Martin Samtmann started as the superintendent at Myers and later went into partnership with him before purchasing 18 acres and starting his own company with his three sons. They produced up to 110,000 plants a year at their peak.

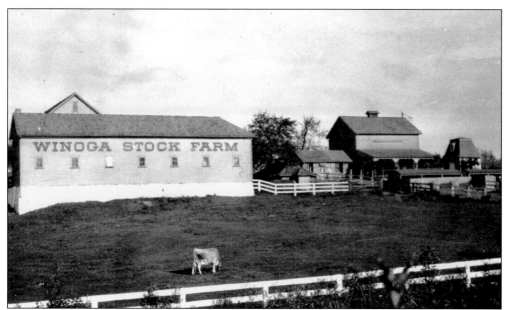

The Winoga Stock Farm was owned and operated by Edward Stotesbury as a horse farm where he kept and trained his award winning "Gentlemen's Roadsters." He named it Winoga after one of his mares who died on this farm. Stotesbury originally purchased this 40 acres of land in 1899, well before he built his famed Whitemarsh Hall just a couple of miles away. This farm was located on the corner of Mermaid and East Lanes, the property now occupied by the Eastern Regional Research Center of the U.S. Department of Agriculture.

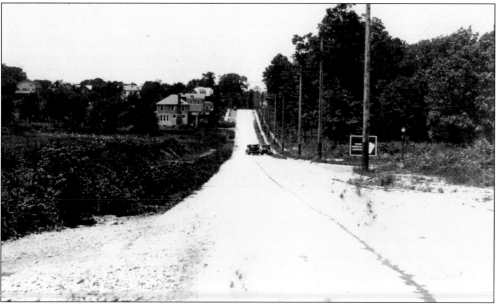

In 1930, Cheltenham Avenue was still a narrow country road running out of Philadelphia into Springfield. Looking west towards the intersection at Willow Grove Avenue, you can see that Mermaid Lane was still a dirt road (left foreground) as is Hillcrest Road, visible on the right at the lamppost. This photograph was taken prior to this area's development in Cheltenham Township.

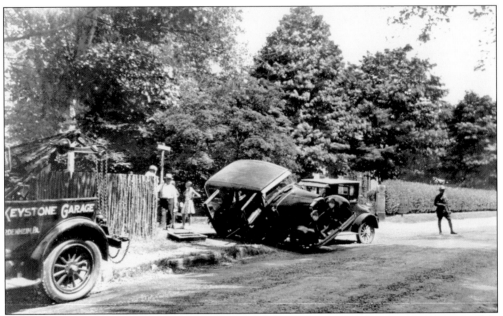

In researching this history, the authors came across a large number of photographs of automobile accidents from the 1920s, surprising considering the relatively few number of automobiles on the road at this time. This photograph was probably taken on Stenton Avenue around Gravers Lane.

The congregation of Grace Lutheran Church held its first communion in April 1902 in the Union Chapel, which became the original Seven Dolors Catholic Church. Two months later, they purchased ground at Willow Grove and Flourtown Avenues. Construction began and the building was completed in 1903. The church was gutted by fire in April 1920, but within three years, the congregation had rebuilt and rededicated the house of worship that stands today. Grace Lutheran has served as a hub of Lutheran and community life in Springfield and surrounding areas.

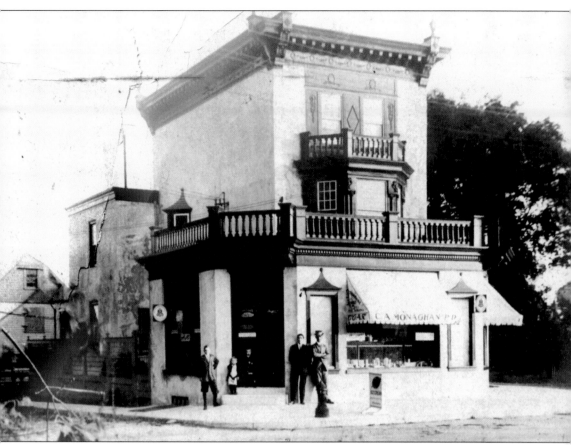

This building has been a fixture and landmark in Wyndmoor for 200 years, located at 812 Willow Grove Avenue. The main street through Wyndmoor was called Limekiln Road back in 1837, when Abraham Unruh purchased the building and 37.5 acres from Elizabeth Rex for $2,425. The original building was most likely a two-story stone structure with one large first-floor room, complete with a cooking fireplace and a spiral staircase leading to two bedrooms. Later, additions extended the building along Elm Street to create the structure that is seen today. In all, there were probably three major additions to the original house, which may have been built as early as 1798. The Unruh family sold the building to Clarence Wenger, who most likely enclosed the original veranda in 1906 to create a store. He rented to Mr. Monaghan, whose drugstore is seen in this picture. The title passed to others through the years, and in 1923, it became Dettry's Drug Store. They remained there for 10 years, until moving across the street. The next owners, Frank Mastroni and Oliver Braun, operated a tavern out of the building. In 1941, they sold the business to their bartender Valentine V. Steigelman, and in 1947, they sold him the building and ground to create the long-running Val's Tavern. Today, another successful tavern occupies the building as Fatty's Bar & Grill.

This photograph of 907 Southampton Avenue in Wyndmoor was taken *c.* 1935. Pictured here are, from left to right, Edward McGettigan, Joseph Timoney, John McGettigan, Thomas McGettigan, Thomas J. Timoney, Clement D. Timoney, and Dolores M. Timoney.

Seen here is James Sullivan, home from World War I in 1919, pictured at 907 Southampton Avenue in Wyndmoor with his parents, Anna Marie Sullivan and Thomas Sullivan. He was in the American Expeditionary Force (AEF), 314th Infantry, 79th Division. James was the first commander of the Arthur Savage American Legion Post in Wyndmoor and chief engineer in the Wyndmoor Hose Company. Thomas Sullivan was a horseman on the local Krumbhaar estate.

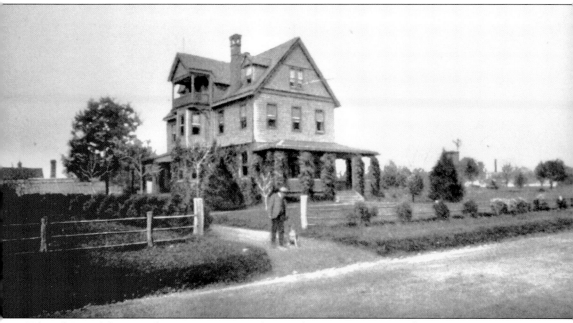

Edward Lonsdale owned six acres in Wyndmoor, fronting on East Willow Grove Avenue, which included this main house, still standing at 1001 East Willow Grove. Also located on the property at the time were a windmill, greenhouses, and a water tower to provide fresh water for the house daily. Research done on this property from 1897 maps shows the general area listed as Spring Village, not Wyndmoor. Today, the home sits between the 7-Eleven store on the right and the Wyndmoor Park on the left.

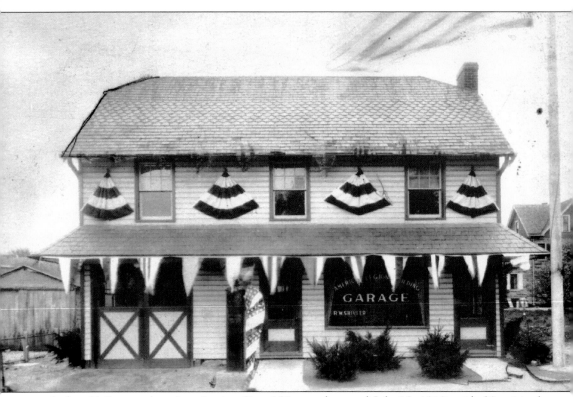

Arthur V. Savage American Legion Post 100 was chartered July 10, 1919, with 39 original members. Located on Elm Street between Willow Grove Avenue and Pleasant Avenue, the post shared this building with Russell Shivler's Garage. The legion operated out of the upstairs (door on the right), and the garage was located downstairs. This picture was taken on a Memorial Day sometime in the 1920s. The legion currently occupies this entire building.

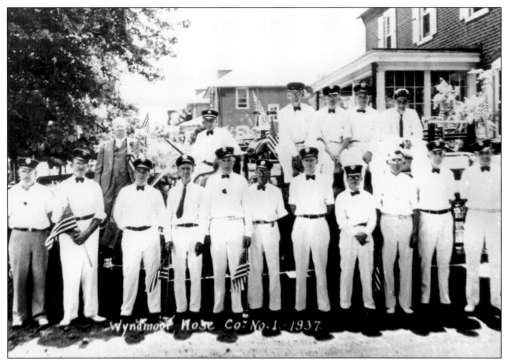

Here is a picture of the Wyndmoor Hose Company, taken in the summer of 1937, on parade at Pleasant Avenue in Wyndmoor. As an interesting side note, Wyndmoor residents once threatened the political existence of Springfield in 1907 when they tried to create a separate borough. This attempt failed when the court ruled that since Springfield was a first-class township, Wyndmoor could derive no additional benefits by incorporating as its own borough. Wyndmoor was first called Bungtown and later Spring Valley. Bungtown was a small village located at the corner of Willow Grove and Cheltenham Avenues. The name Wyndmoor was adopted in the mid-1890s.

This is the original rectory building for Seven Dolors parish, located at the corner of Queen Street and Willow Grove Avenue. It was razed when the priests moved into the present-day rectory in 1956.

These are the children who went on to become part of the "greatest generation." The boys enlisted in different branches of the service in World War II; two were killed in action. The picture was taken next to the original Seven Dolors church, which was later torn down. Pictured from left to right are the following: (front row) A. Wieber, T. Murray (killed in action on June 10, 1945), J. Mangan, Joe Timony, Tom McGettigan, Ed Danaher, and Ollie Brown; (middle row) Louise Olson, Julia Taylor, Helen Reid, S. Mastroni, Helen Alford, J. Winning, M. Ardent, Helen Plewinski, unknown, and M. Wilmarth; (back row) Jim Ralph, Jim O'Donnell, Joe McNulty, Frank Mertin, unknown, Ernie Schmidt (killed in action on October 8, 1945), Kitty Jones, Mike Ralph, L. Carrambone, Frank Lyons, John Miller, Tom Fitzpatrick, Gene Koons, and Frank Coar.

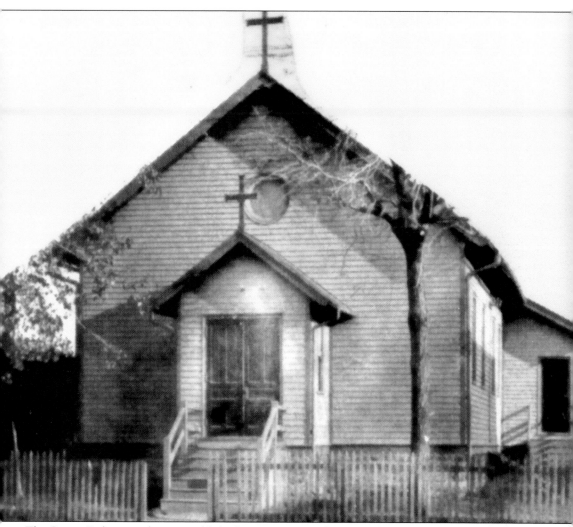

The Seven Dolors parish was established in 1907, using the original church pictured. In 1950, Seven Dolors purchased the Reformed Missionary Society Church, and the first mass was conducted there in April of that year. It was expanded two years later by adding two wings and a belfry. The present-day church was dedicated on May 24, 1963, with Cardinal John Krol presiding. Recently, Seven Dolors has merged with St. Genevieve in Flourtown, as the boundaries of the Flourtown parish are redrawn to include Wyndmoor. The church remains open for Sunday mass and funerals but is slated to close its doors in July 2003.

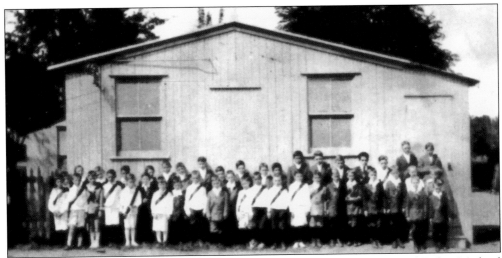

The Seven Dolors School opened on January 7, 1918, under the leadership of Father Michael J. Corley. The parish was already 11 years old at the time, and they wanted to add a school to hold weekly Confraternity of Christian Doctrine (CCD) classes. The Sisters of the Immaculate Heart, located in Germantown at the Immaculate Conception Parish, made the trip to Wyndmoor via trolley and jitney. The school building was formerly a Protestant church and consisted of two rooms with a coal-fired hot-air heater. In 1918, work began on a new school building, which was completed and ready for occupancy by July 1921.

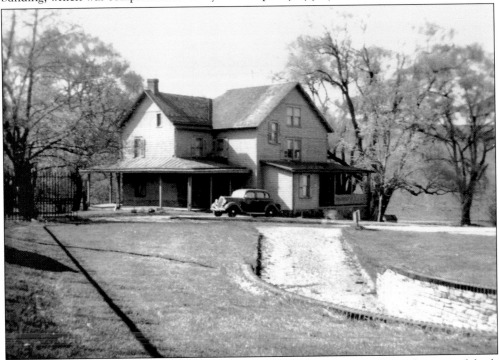

This was the Steele house, located at 8404 Cheltenham Avenue in Wyndmoor and built c. 1800. Mr. Steele managed the greenhouses for Edward Stotesbury's Whitemarsh Hall estate and was responsible for the rough topiary work, such as bushes and trees. The house is still standing today and is maintained as a private residence.

Here is the freshman class of Springfield Township High School outside the old Wyndmoor School in 1923. Prior to the completion of the township high school (Hillcrest), students could choose to go to Abington or Cheltenham senior high for grades 10 through 12. In the fall of 1923, for the first and only time, a 10th grade was held in the Wyndmoor School, seen here in this picture. This was to keep a group together in readiness for Hillcrest, which opened in 1924. The Wyndmoor School was built in 1893, and a second story was added in 1905. It still stands at 1400 Willow Grove Avenue and has been used as a Montessori School since 1965.

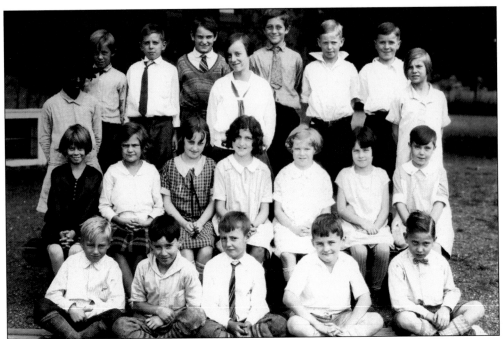

It was common in Colonial times for the churches to provide schooling and education for the children. In 1833, when the state legislature established a general system of education, there was much opposition to this act, fearing that the separation of the schools from the church would tend to draw the children away from the church. The township did not accept the public school system until 1842, when schools were opened for four months of the year. By 1883, there were four schools in the township open for 10 months of the year. The Oreland School on Plymouth Avenue was built in 1897, and this photograph shows students in 1928 outside of the building.

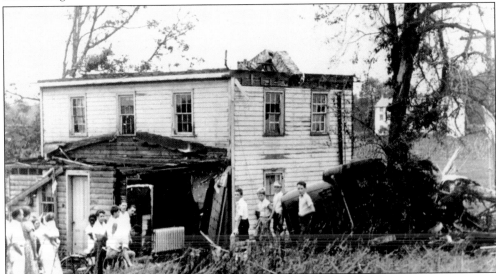

In 1935, a tornado ripped through Springfield, touching down in the Oreland section of the township. This house, located at 513 Paper Mill Road, had its roof torn off and suffered major damage but was later repaired.

106

This barn across from 415 Oreland Mill Road in Oreland was another casualty of the 1935 tornado. The boy in the baseball cap (second from the left) is identified as Leonard B. Mower.

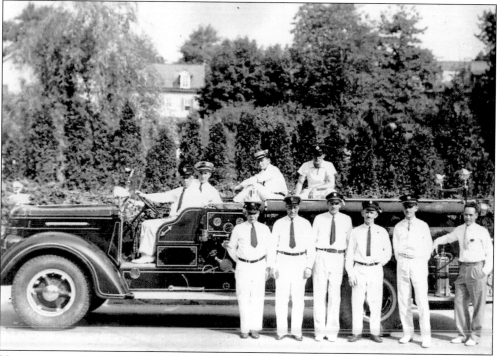

Here is an early photograph of the Oreland Volunteer Fire Company. The company was established in 1908 and grew into service with Oreland's rapid growth just prior to World War II. A firehouse was built in 1912 at Roesch and Ehrenfort Roads that was in operation until the present house was built in 1980 on Bruce Road east of Bridge Street.

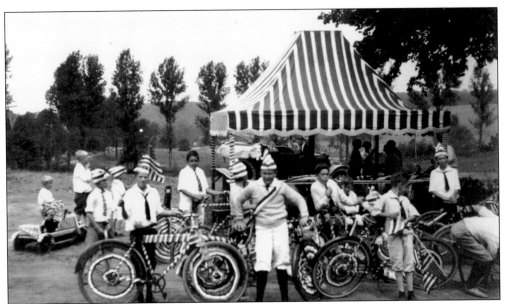

As far back as the 1920s, the Oreland Fourth of July parade has given children the opportunity to decorate their bikes and wagons in order to participate in the celebration and demonstrate their national and civic pride.

Here is a wintry view looking east down Plymouth Avenue in Oreland. The earliest settlement in this section of the township appears to have started in the vicinity of Plymouth and Walnut Avenues c. 1840. It is known that there was at least one general store there, and one of the first schools in the township was constructed on Plymouth Avenue.

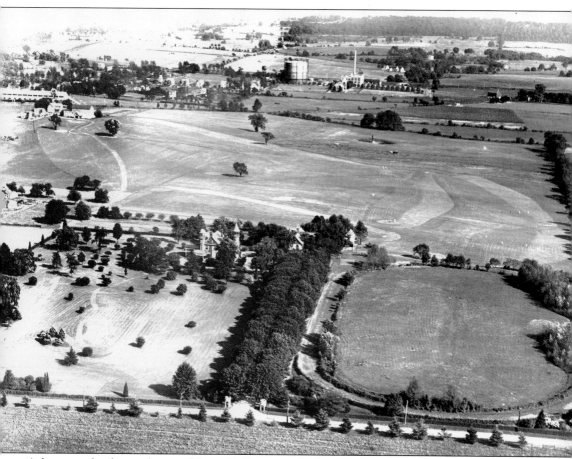

Arlington, the former home of Irene DuPont Hendrickson Ralph, can be seen in this aerial photograph of Sandy Run Country Club. The club was chartered in 1923 under the name of Edge Hill Golf Club. The club acquired 115 acres of the former I.D.H. Ralph estate for $1,000 per acre. In 1927, the club was renamed Sandy Run Country Club, taking its name from the stream that runs through the property. Arlington was used as the original clubhouse until it was demolished in 1954 and replaced with the current clubhouse. The house was situated in the area where the club's main practice green is located today. Notice in the background of this picture the water tank and power station on Plymouth Avenue and, beyond that, the North Hills Country Club.

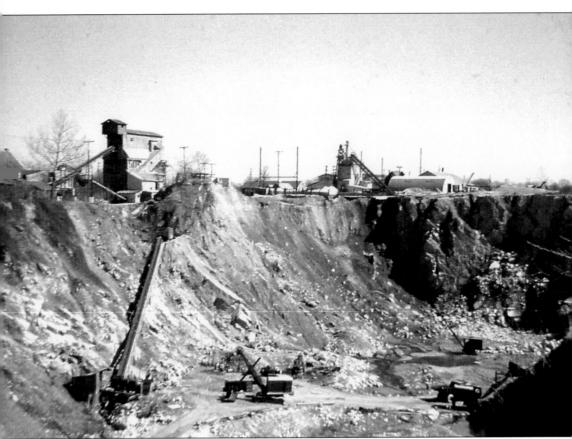

The quarry on Walnut Avenue in Oreland was mined for stone and ore starting in the late 1800s. By 1938, it was being operated as the Oreland Crushed Stone Company on 13.9 acres, with Nicholas Cascetti as the owner. A number of homes, named Springdell Cottages, were built next to the quarry and were occupied by some of the workers and their families. In 1958, a snowstorm knocked out power to the area for several days. Without the electric pumps, the quarry rapidly filled with water, putting the excavation operation out of business. The U.S. Navy later bought the property as an underwater experimental and torpedo-testing station.

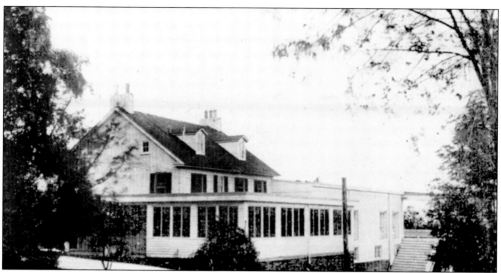

The Edge Hill Golf Club (North Hills Country Club) was formed in 1908 under the design and presidential leadership of J. Franklin Meehan. Land was leased from the Edge Hill Land and Improvement Association to create the nine-hole course. The club was incorporated in 1910 as North Hills Country Club. Additional land was later leased, and finally purchased, to complete the 18-hole course in 1913. The first clubhouse was the old James farmhouse on the approximate site of the Oreland Swim Club. In September 1911, the club moved to its current location on Station Avenue. This building was later demolished in favor of the present-day clubhouse. Charter membership was originally just $25.

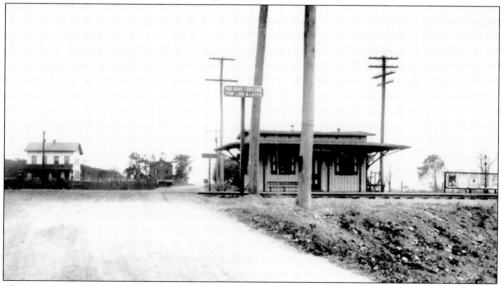

The North Pennsylvania Railroad created the Edge Hill train station as a stop in 1855. It became North Glenside in 1923 and North Hills sometime between July 1931 and January 1932. In this picture, taken from the Abington side looking into Springfield, the road running over the train tracks is Station Avenue. The houses on the left side of Station Avenue are gone. The one in the foreground served as the office for the Edge Hill Iron Company, which was in existence from 1868 to 1872. Notice the signage to the right of the station. The present-day station was built in 1931.

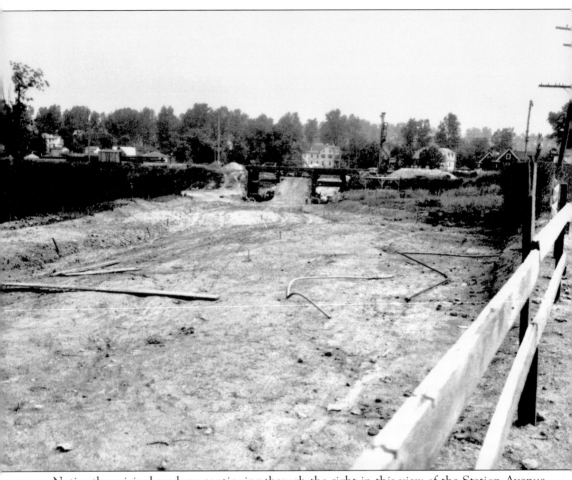

Notice the original roadway continuing through the right in this view of the Station Avenue underpass being built in 1929. Station Avenue was laid down c. 1897, connecting Church Road to Pennsylvania Avenue. The underpass was built to prevent schoolchildren and automobiles from following Station Avenue across the railroad tracks. Today, the original roadway can be traced by following Station Avenue straight through the North Hills train station parking lot, over the train tracks via a set of cast-iron gates, and to the other side where the street continues on, dead-ending into Pennsylvania Avenue. Several township roads crossed train tracks. In addition to the rerouting of Station Avenue, both Paper Mill Road and Oreland Mill Road were terminated along the same lines of the Reading Railroad, now part of the South Eastern Pennsylvania Transit Authority.

Nine

POST–WORLD WAR II
URBAN DEVELOPMENT

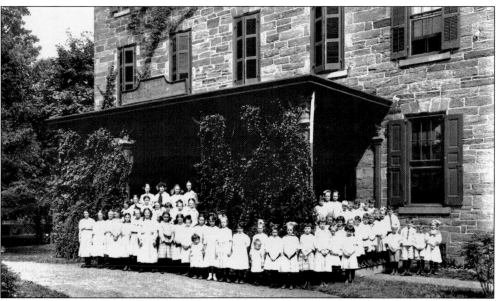

Here is a post–World War II photograph of Bethesda Home on Stenton Avenue between Willow Grove Avenue and Mermaid Lane. In 1860, Annie Clements, who was affiliated with the Methodist Episcopal Church, was offered a large home for rent in Wyndmoor for $600 per year. The home was established as a peaceful retreat for the aged and a shelter for orphans and was entirely supported by voluntary subscriptions. In 1872, Henry J. Williams, Esq., built a large house on the site as a home for orphaned children. Williams was a distinguished Philadelphia lawyer and son of Gen. J. Williams, who was the first superintendent of West Point. From its inception until its closing in 1954, it provided a home, education, and care for many children. The home also was the original site for carnivals operated by the Wyndmoor Hose Company. The home was razed after 1954, and the property was developed for single homes.

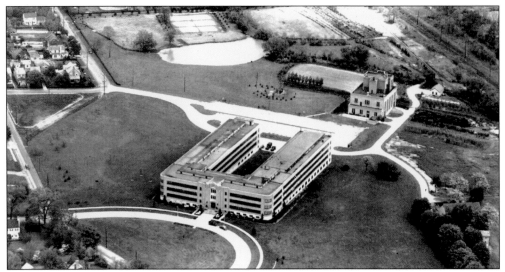

Land was purchased in 1938 by the U.S. Department of Agriculture to construct this building, which opened in 1939 to house the Eastern Regional Research Center. On Mermaid Lane in Wyndmoor, this building is located on ground once owned by Edward Stotesbury for his Winoga Stock Farm. Along with Mermaid Park, which adjoins the center's extensive grounds, this area remains one of the few large tracts of open space remaining in the township. This section of Wyndmoor remains an industrial area to this day.

The land where the Veteran's Memorial now stands was once the site of carnivals held by the Wyndmoor Hose Company. This is now known as Veteran's Park on the west side of Willow Grove Avenue between Traymore and Southampton Avenues. The inscription on the monument reads, "Honor Roll dedicated to those of East Springfield Township who answered their country's call in the War." Wars listed are World War I, World War II, the Korean War, and the Vietnam War. The memorial plaques were originally located on Willow Grove Avenue where the Montessori School now stands.

Upon Edward Stotesbury's death, his wife, Eva, sold the mansion and 30 acres to the Pennsylvania Salt Company. Matthew H. McCloskey Jr. purchased 265 acres of the estate to be developed into 1,000 homes known as Whitemarsh Village, intended for former servicemen returning from the war and priced at $8800 to $9800 per home. Construction of the development started *c.* August 1946. Edward and Winifred Zwicker owned this house at 8327 Childs Road, pictured here in 1953, for almost 50 years. The house was typical of the architectural style being developed for Whitmarsh Village and represented suburban living at its finest. Today, the entire 300-acre tract has been developed, although some remnants still remain of the former splendor of Whitemarsh Hall, including the pillars that held up the portico, the garden retaining walls, and one of the belvederes.

By 1953, Whitemarsh Village had become a well-developed residential neighborhood. This photograph was taken from Childs Road, looking out over the valley to Cheltenham Avenue. The clearing on the hill past Cheltenham Avenue is where LaSalle College High School would later be developed. The ground in front of the avenue would be used for a residential development, Stotesbury Estates, in the 1980s.

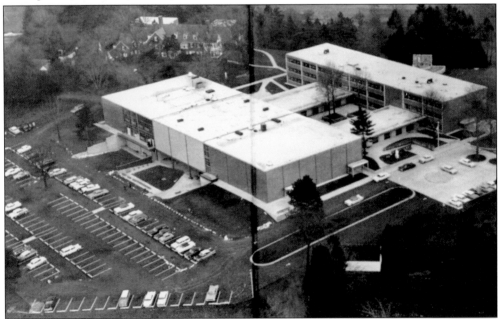

In 1958, LaSalle College of Philadelphia bought this property from the executors of the Clarence Brown estate and established the LaSalle College High School at 8605 Cheltenham Avenue in Wyndmoor. This 1962 yearbook picture from the school shows the past and the present, with the school facing the road and the Brown mansion situated behind. The mansion is still well maintained and today is used as a residence for the brothers of LaSalle and for various school activities.

116

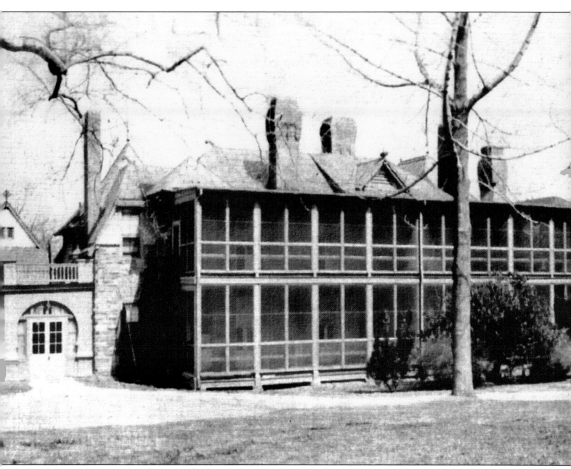

On May 3, 1886, the Episcopal City Mission opened the Home for Consumptives at 8601 Stenton Avenue in Wyndmoor. Designed by Frank Furness, there were two structures: a massive main building with offices, reception rooms, meeting hall, and chapel; and a brick-and-stone cottage that housed patients (since demolished). The 40 female patients were attended by 2 female resident physicians, a board of consulting physicians, 7 nurses, and 7 servants. The Home for Consumptives quickly became Philadelphia's leading tuberculosis clinic. By 1916, the facility included nine buildings and could accommodate 90 male and female patients. The home also became one of the country's leading centers for tuberculosis research in the years before World War II. In 1958, it changed its name to All Saints' Hospital for the Treatment of Chronic Diseases. In 1965, the tuberculosis unit was formally closed. During the 1970s, All Saints' began to focus on rehabilitative therapy, changing its name again to All Saints' Rehabilitation Hospital. In 1987, both All Saints' and its sister organization, Springfield Retirement Residence, were acquired by Chestnut Hill Health Care, the parent organization of Chestnut Hill Hospital. Today, as Chestnut Hill Rehabilitation Hospital, it helps patients recover from a variety of illnesses and injuries. At the heart of its campus, surrounded by up-to-date structures, is the original Home for Consumptives (the front porches have been removed), now used as an administration building.

This 1946 photograph shows a wartime scene in the Bloomfield Farm section of the Morris Arboretum. During the war years, the farm joined the production effort by raising cattle on both the Compton and Bloomfield sections of the Arboretum property. Through 1946, the farm produced 70,000 pounds of beef. Gerald Buckler, who was manager of St. Joseph's Convent Farms, had responsibility of ownership and supervision of the cattle.

A view looking north on Bethlehem Pike shows Springfield attempting to dig out from the blizzard of 1966. The row of stores on the right side of the Pike is now the site of the Flourtown CVS and Farmers' Market.

118

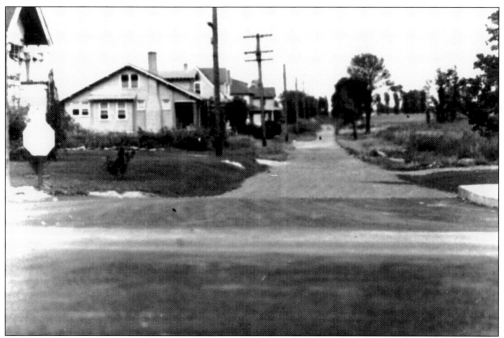

Here is a view taken from Bethlehem Pike looking down Bysher Avenue. The Bysher name came from the longtime Flourtown family of the same name. The second house on the left in the picture still exists. The area has been commercially developed, with the Wine & Spirits Shoppe on the right corner and Collex Collision Service on the left corner.

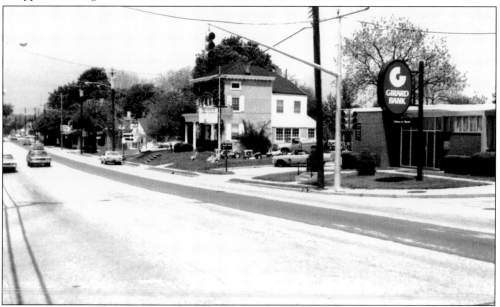

The corner of Bethlehem Pike and Wissahickon Avenue has been witness to many changes in the history of Flourtown. Once the location for a tollgate on the pike, it has seen the pike widen through the years to allow for increased traffic and development. The Girard Bank was located on the corner in the 1970s and now houses MAB Paint store. The building to the left of the bank is still there today.

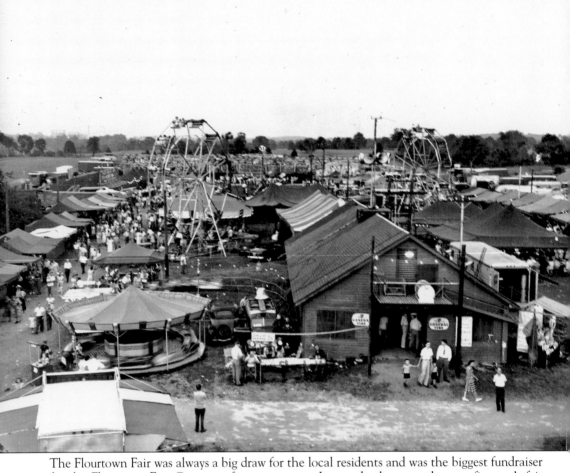

The Flourtown Fair was always a big draw for the local residents and was the biggest fundraiser for the Flourtown Fire Company for many years. It was the largest volunteer fireman's fair in the state and was estimated to have as many as 10,000 attendees in a single night. It was differentiated from the Wyndmoor Fireman's Carnival in that Flourtown's had not one, but two, Ferris wheels. The fairgrounds are the present site of the Flourtown Swim Club. The land is still owned by the Flourtown Fire Company and rented to the swim club. The fair was discontinued in 1950.

The reconstruction of the former Flourtown Fire Company building can be seen in this 1950s picture of 1528 Bethlehem Pike. Cisco's Bar is to the left of the building. The house shown to the right, built in 1812, was torn down to build the new firehouse. Today, this building is home to Mount Airy Auto Parts and Men's & Ladies' Sportswear and Outerwear. The stone inscribed "Flourtown Fire Co." still adorns the building today.

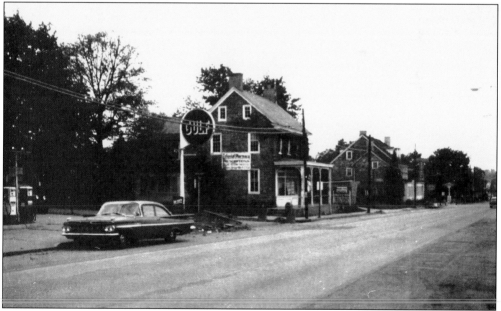

The Colonial Pharmacy was located on the corner of Weiss Avenue and Bethlehem Pike and was still in operation in 1959, when this photograph was taken. This building was originally a farmhouse built c. 1742. Its last use was as a pharmacy before it was torn down. Although the house has long since been replaced by a Wawa Market, both the Gulf station and the building to the right (Halligan's Pub) are still fixtures on the Pike today.

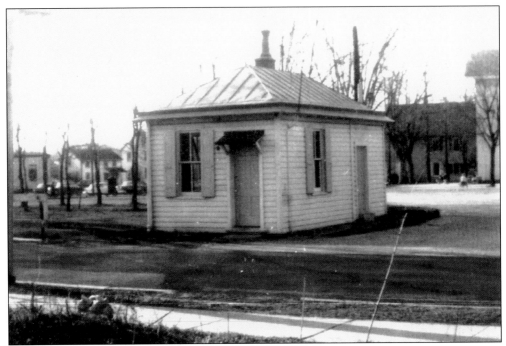

This small wooden building, located on East Mill Road on the former site of McCloskey's coal yard, served as the weigh station for the coal yard and later as Flourtown's first library. The authors were not able to verify when this structure was removed, but the picture was probably taken in the early 1940s. First Presbyterian Church is seen on the right side of the building, and houses on Bethlehem Pike are visible on the left.

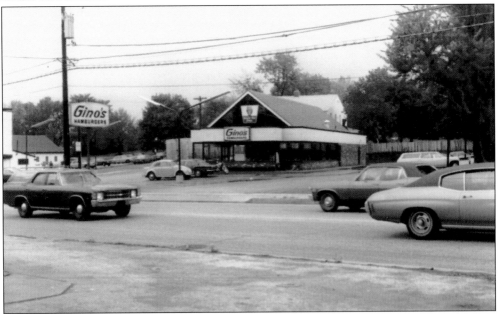

Once located at 1722 Bethlehem Pike and part of the early commercialization of Bethlehem Pike in Flourtown, Gino's was the first fast-food restaurant in the township. The property is now part of the Springfield Commons complex, which houses Chestnut Hill Cardiology.

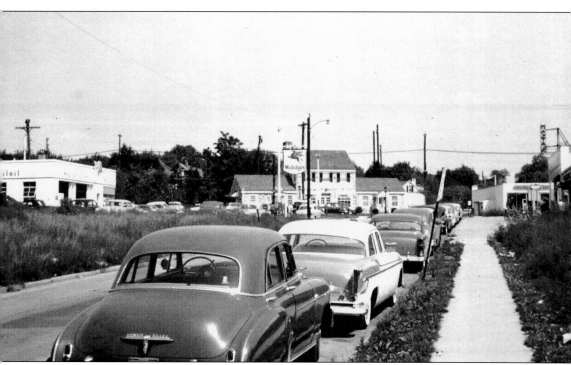

The youngest of Springfield's communities, Oreland has grown from a small settlement begun at Plymouth Avenue and Walnut Avenue, *c.* 1840, although the area had a few scattered residents much earlier. Oreland's earliest inhabitants were Germans who turned much of the land into prosperous farms. During this early period, the only industries were the gristmill, which stood on Sandy Run near the present railroad tracks, and the limekilns. Although lime burning was carried on throughout the township, the first kilns were in Oreland. This picture was taken from Allison Road looking towards Bruce Road. Many of Oreland's landmark buildings, including the gas station, bank, and hardware store, are still in operation today.

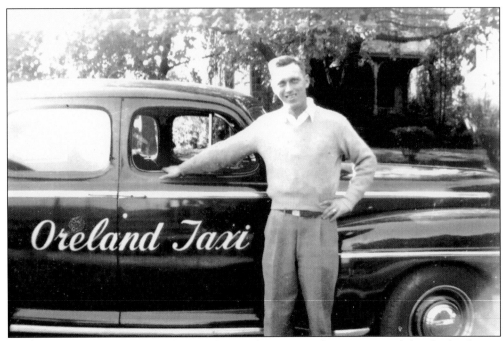

John J. Walsh is a local township resident and ran a taxi business out of the Oreland train station from 1956 to 1961. His cab fare cost passengers all of 50¢ per mile.

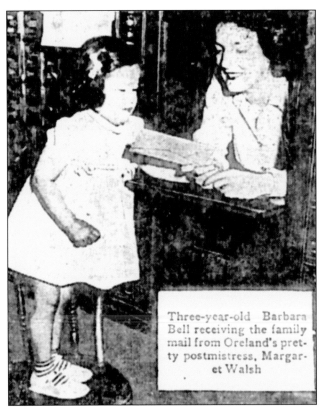

Three-year-old Barbara Bell receiving the family mail from Oreland's pretty postmistress, Margaret Walsh

Margaret Walsh was believed to be the youngest postmaster in the United States, starting her position at the age of 22. She succeeded retiring postmaster A.L. Aiman, who was 74. The post office was in the general store of Mr. and Mrs. Aiman on Plymouth Avenue. This post office served the 900 residents of Oreland, each of whom had to pick up their mail from Walsh, as there was no home delivery at that time.

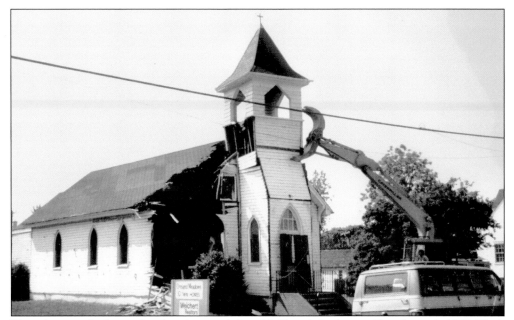

This photograph shows the demolition of the old Christ's Lutheran Church in the 200 Block of Plymouth Avenue in Oreland. This church was chartered in 1903 with a congregation of 20 members. Services and church life flourished in this location until a larger house of worship was constructed and dedicated in 1959 on its present site of Pennsylvania Avenue and Rech Street in Oreland. Dr. Mervin Rosenberger, a member of the congregation and the owner of Linden Lawn and the George Emlen farmhouse, had donated the ground for the present church. The original church was torn down in the 1980s to make way for the Oreland Meadows development.

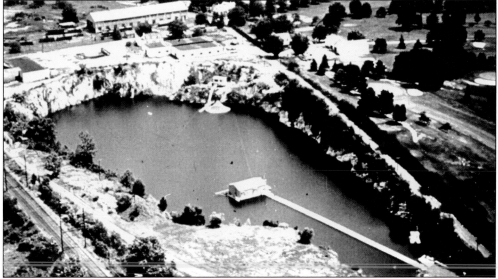

Here is a recent view of the Oreland quarry, facing east, with Walnut Avenue on the right and the SEPTA lines to the left. After the storm in 1958 that knocked out power and caused the quarry to flood, the U.S. Navy bought the property for an underwater research and torpedo-testing station. It was later donated by the federal government to Springfield Township. Plans are being considered for future use, including open space or parkland.

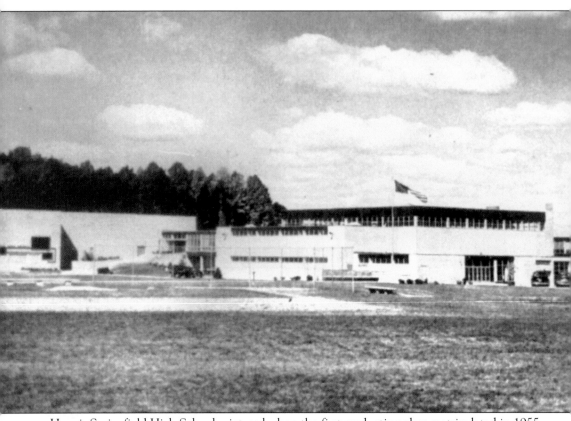

Here is Springfield High School, pictured when the first graduating class matriculated in 1955. The school was built in 1954 at a cost to taxpayers of $2,371,587. The school was designed to accommodate the rapid population growth in the township after World War II. Additional schools were built in these years, including Wyndmoor Elementary (1950), Erdenheim Elementary (1955), Enfield Junior High School (1958), and Penn Manor Elementary (1965). The excellent school system in Springfield was a drawing attraction to people moving into the township and contributed to increasing home values and prosperity in the 1950s and 1960s.

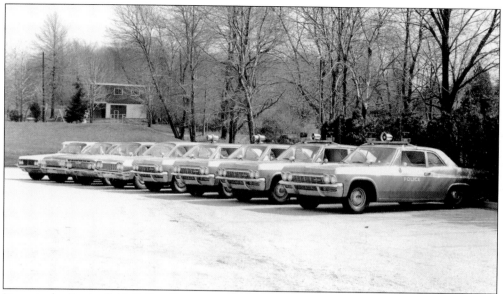

Here is the Springfield Police Department's fleet of Chevy Impalas in 1973. The dramatic growth of the township in the 1950s and 1960s was evident by the increase in public services. The police budget in 1976 was $563,000, which paid for a staff of 33 uniformed policemen. It was a dramatic increase from the two part-time officers of 50 years prior, and it was a larger budget than that required to operate the entire government in the 1950s.

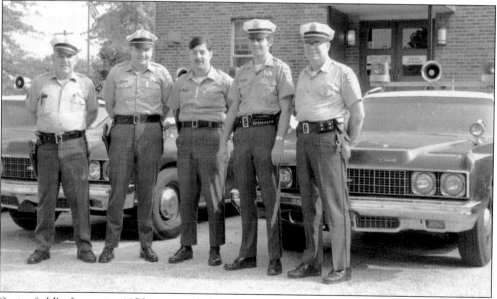

Springfield's finest in 1973, pictured from left to right, are Aubrey Williams (sergeant), Raymond Potter (officer), Raymond McMahon (dispatcher), Jack Thompson (officer), and Lloyd Clemmer (safety officer). They are standing in front of the township administration building on Paper Mill Road. The land for the administration building and later the Springfield Library (1966) was donated by Clarence M. Brown in 1955. This replaced the old township building in Flourtown and provided more modern facilities and space for a growing township and government.

ACKNOWLEDGMENTS

The authors and Springfield Township Historical Society were very pleased to work with Arcadia Publishing on this pictorial portrayal of historic Springfield Township. It was made possible by the hard work of the historical society's book committee, composed of Cynthia Hamilton, Edna Jones, T. Scott Kreilick, Christine Smith, and Joseph Timoney. Additional researchers who provided valuable input included Tony Giovinazzo, Deborah C. Wilson, and Edward C. Zwicker III.

The pictures for this book came from a variety of public and private sources and include many never-before-published images. To each of these institutions and individuals we express our heartfelt thanks for sharing their photographs with the readers of this book and for allowing these images to become a permanent part of the history of our township.

Contributions came from Albert Comly, Arthur V. Savage American Legion Post 100, Dan Helwig, Ann and Charles Hepburn, Robert Hibbert, Dolores Jordan, LaSalle College High School, Tonya Nagy, Edith May Root, Springfield Township Historical Society, Springfield Township School District, Robin and William Stubanis, Joseph Timoney, Richard Weaver, Muriel and Edward C. Zwicker III, and Winifred L. Zwicker.

Special thanks go to the following people for their past research and documentation of Springfield Township, which proved invaluable in the creation of this book. The late Marie Kitto was the driving force behind the founding of the historical society; she tirelessly documented many of the township's oldest buildings through deed research and pictures. Aubrey Williams, a former Springfield Township police officer, authored an unpublished manuscript of Springfield's history, from William Penn through the present day. Velma Thorne Carter brought together the work of Aubrey Williams and others in her 1976 bicentennial book, *Penn's Manor of Springfield*.

And last, but not least, special thanks go to our wives, Marianne and Joy Lynn, for supporting us through the many months of work, including the late nights and weekends, to research and write this book.